JIM LEEDY

Artist Across Boundaries

JIM LEEDY

Artist Across Boundaries

MATTHEW KANGAS

Kansas City Art Institute
in association with University of Washington Press, Seattle and London

Dedicated to the artist's parents, Sarah and Dick Leedy

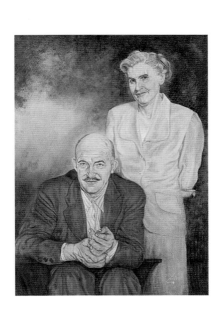

In captions, height precedes width precedes depth. Measurements are given in inches unless otherwise noted.

Cover: *Expressionist Plate with Blue X* (detail), 1969. Stoneware with engobes, 21 x 22 x 7. © Philbrook Museum of Art. Photo: E. G. Schempf.
Endpapers: *War* (details), 1999. Mixed media and found objects, 12 ft. x 47 ft. Photos: James Walker.
Frontispiece: *Floating Fragments* (detail), 1959–1969. Oil on canvas with clay additions, 76 x 59. Photo: James Walker.
Page v: *Sarah and Dick,* 1949–1950. Oil on canvas, 25 x 18½.
Page xv: *Plate* (detail), 1988. Stoneware with insertions, 17 x 17 x 2. Photo: E. G. Schempf.
Page 160: *Dream*, 1946. Woodcut on ricepaper, 19 x 11.
Back cover: *Creation* (detail), 1995. Acrylic on paper mounted on wood, 48 x 97. Photo: James Walker.

Production Manager: Phil Kovacevich
Designers: Phil Kovacevich, George Lugg
Project Editor: Xavier Callahan
Proofreader: Laura Iwasaki

ISBN 0-295-97936-4

Matthew Kangas and Jim Leedy warmly thank James Walker for his outstanding photographic work.

All photographs with known attributions are by James Walker except as follows: Donald Bendel (p. 102, left), Jennifer Crane (p. 74, right), Larry Dean (p. 91), Glenn Hagbru (p. 110, left), Eva Heyd (p. 40, bottom), Paul Macapia (pp. 41, top; 47, right; 50, top), Jacob Melchi (p. 67), Robert Newcombe (p. 57, left), E. G. Schempf (pp. xv; 11, bottom; 22; 38; 40, top; 45; 46, top; 48; 52; 57, right; 65; 78; 79), Al Surratt (p. 51), and Jean Vong (p. 74, bottom left).

Distributed by University of Washington Press
P.O. Box 50096
Seattle, WA 98145

Printed in Hong Kong by Palace Press International

CONTENTS

ACKNOWLEDGMENTS

The author and the publisher gratefully acknowledge the following contributions
to the production of this volume:

Underwriters

Suzie Aron and Joseph W. Levin

Rudy Autio

John Buck

Dale Chihuly

Sherry Cromwell-Lacy '72 and James W. Lacy

J. Scott Francis '87

Linda Lighton-Adkins '89 and Lynn Adkins

Barbara Hall Marshall

Margaret H. Silva '85

Peter Voulkos

Patrons and Friends

Kathleen Collins and Jeffrey Love

Jackie Golden

Dick and Jane Hollander

Dennis and Carol Hudson

Sybil and Norman B. Kahn

Hugh J. Merrill

Kansas City Art Institute Alumni

Eric Abraham '63

Michael J. Bauermeister '79

Rita Blitt '55 and Irwin Blitt

John E. Buck '68

Matthew Crane '94

Laura A. Davis '83

Julia A. Dougherty '96

Ming G. Fay '67

Veronica M. Fernandez '91

John C. Fernie '68

Kate Hunt '79

Ke Sook Lee '82

Lisa Lewenz '77

David Luffel '79

Jay S. Markel '76

Kent T. McClure, AIA, '80

Ryozo Morishita '73

Thomas R. Ostenberg '95

Derek C. Porter '89 and Anne M. Lindberg

Patricia A. Pummill-Betteridge '68

Clee Richeson '97

Barbara B. Robison '95

Mrs. Samuel T. Rowell '49

Patricia Showman-Nelson '77

Edward Stanton '68

Robin Taffler '77

Marcia Turner '96 and Flower Turner

Mark A. Wallis '78 and Christina A. Wallis '95

Paige Wideman '89

David Yaffe '88

PREFACE

This publication is a natural extension of the Kansas City Art Institute's interest in the professional enrichment of both students and faculty. From the beginning, our mission has been to create a learning environment for artists that reflects the entire tapestry and texture of the visual arts as they are created in our nation today. Jim Leedy, on our faculty since 1966, has been a pioneer in so many areas that it has taken this book to corral all of his work into a manageable whole. The result is a new look at an artist who may be loved by many students and recognized by close friends and peers but whose work also deserves to be far more widely appreciated and understood.

Many individuals and institutions have been responsible for the coalescence of this project and deserve to be thanked. A special committee of supporters was formed to assist in developing and making possible the most beautiful art book imaginable. They include Suzie Aron, Emily Eddins, Richard Hollander, Jr., Linda Lighton-Adkins, John O'Brien, and Margaret Silva. Without their undaunted dedication, this book simply could not have been created. In addition, heartfelt thanks to Sherry Cromwell-Lacy, independent curator, who with grace and professionalism acted as liaison between the college and the other fundraising and editorial agencies.

Jim Leedy's family—including his daughter Stephanie; his son-in-law Jim Walker, who took so many beautiful photographs; and his close friend, Molly Forman—took upon themselves the enormous task of cataloging, photographing, and documenting all of the artist's collection, without which work this book could not exist.

In addition, there are many other individuals to be acknowledged who supported this project. They include Terry Nygren, vice president for advancement, who shepherded all the parties involved and oversaw the project on behalf of the college, and all our friends and alumni listed as donors, especially Suzie Aron and Joseph Levin, Sherry Cromwell-Lacy and James Lacy, Scott Francis, Linda Lighton-Adkins and Lynn Adkins, Barbara Hall Marshall, and Margaret Silva.

We are grateful to the author, Matthew Kangas, for his unflagging dedication and meticulous efforts over a five-year period, and for his suggestion of the idea of a book on Jim Leedy. The production team in Seattle included the book's designers, Phil Kovacevich and George Lugg of Kovacevich Design, who made the book the elegant presentation that it is; the project editor, Xavier Callahan; and the proofreader, Laura Iwasaki.

Pat Soden, director of the University of Washington Press, was enthusiastic from the beginning about distributing the book. We are grateful to him and to the Press for their patience, cooperation, and thorough support in helping this book reach its widest possible audience.

Finally, I am grateful to a dedicated faculty member and artist, a friend whose kindness knows no limit, Jim Leedy. His encouragement of students and colleagues alike has enriched the climate of

teaching at the Kansas City Art Institute. Jim's advocacy for the arts has also led to a resurgence in the entire art community of Kansas City and beyond. As the pioneer for Kansas City's art district, Jim has brought many artists, business owners, students, and new audiences to appreciate and support the city's growing visual arts community. The flourishing seven-block area near downtown Kansas City, where Jim opened his art gallery about fifteen years ago, is now affectionately referred to as "Leedytown." Truly an artist who crosses boundaries, Jim Leedy has crossed into many people's lives and made a difference with his life and his art.

Kathleen Collins, *President*
Kansas City Art Institute

FOREWORD

The alignment of Jim Leedy with the abstract expressionist movement of the 1950s proved to be a catalyst for a new direction and aesthetic in ceramic art; the originality and vitality of his work seem even more evident today. It is not only the abstract expressionist movement that has influenced Leedy, however; Eastern philosophy and culture also have a positive place in his thinking and in his understanding of life, especially as he searches for new forms and a new aesthetic.

Leedy confronts the unknown and mysterious. He never takes the obvious path. Rather, he forges a new path, one of discovery and chance. It is Leedy's academic background and intellectual approach to his work that distinguish him among contemporary artists expressing themselves in clay. His analytical and intuitive search for form and matter has positioned him as an influential and original artist. Even his lectures are performances in which philosophy and ideas are expounded in a unique manner.

Nowhere in the contemporary art world is there another art form that so invigorates the sense of intellect, of tough and bodily presence, as does ceramics. In many ways, the vessel represents the ultimate three-dimensional form, the inner and outer boundaries representing the terms by which we interpret presence and measure the space of reality.

Leedy's vessels are handbuilt axial forms that represent a vertical "being," a formal construction suggesting the human figure. His vessel forms, rooted in the most basic concerns of survival and ritual, comment on the preoccupations of a contemporary society and culture that he sees are in perpetual disintegration and contradiction as artists are forced to deal with their different beliefs in humanity. The aesthetic and formal language of Leedy's vessels is the visual link from the mind through the hands. His *Stilted Vessel* series, for example, demonstrates the transition from intellectual ideas to physical form. So close is this bond between idea and form that the vessels not only represent a metaphor of the human body but also become the artist's self-portraits.

The philosophy and literature of this century are much concerned with the idea of man as a separate being, with an emphasis on the individual. Artists in particular express the sense of self through their work. A few artists, however, in their pursuit of individuality, also achieve the unique quality through which a work of art becomes the artist's signature, as is the case for Jim Leedy. His work is so distinctively his own that it cannot be copied. He is in a continuous search, reassessing and developing his ideas. It is not skill and perfection in his work that he seeks, however, but rather the expression of dynamism and surrealism. His work is avant-garde, disconcerting and provocative; it evokes emotional responses. The vessels, for example, are structures of uncertain balance and provoke a feeling of insecurity. Leedy has crossed media in his artistic search, and he has synthesized and accumulated

knowledge, mastering painting in his sculpture. The energy and playfulness of his work suggest confidence, which in turn gives the forms a sense of strength and power.

Although critics have mentioned the notion of a fantasy prehistoric culture evoked by Leedy's ceramics, his work does not symbolize a dead culture. On the contrary, his ideas represent notions of identity prevalent in our present time—those relating to emotions, feelings of insecurity, and contradiction. His art fascinates by its extraordinary metamorphic effects, carried out in surface imagery, colors, textures, and relief and transformed by fire.

Apart from his ceramics, Leedy's other artistic endeavors are equally impressive. Through a career that has encompassed paintings steeped in abstract expressionism as it developed in New York, in addition to prints, performance art, and installation art, his imagination and vision have remained consistent with his artistic goals. Systems that are open rather than closed; the act of stretching materials' properties to their limits and beyond; the disruption of categories to accommodate them to broader possibilities—these are the threads that Leedy has sustained throughout his creative life.

The reason for Leedy's success, I believe, lies in his combination of knowledge and intuition. This combination results in his need to take chances, a need to try the "wrong" way and discover the unexpected. Jim Leedy has had the courage to venture into the unknown, and the confidence to believe in his ideas. In so doing, he has become an American original.

Ole Lislerud
National Academy of Art and Design
Oslo, Norway

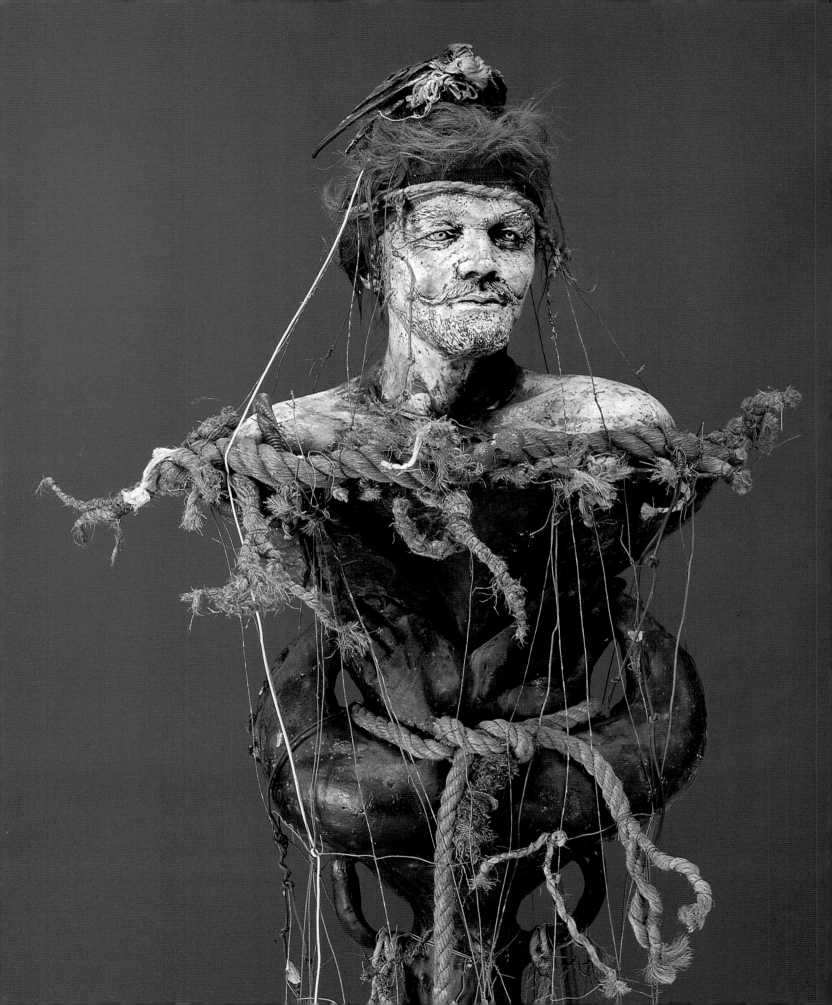

ARTIST ACROSS BOUNDARIES

The art of Jim Leedy is a vast, tattered tapestry mixing painting with sculpture, prints, drawings, ceramics, installations, and public art. It is not a tidy oeuvre, reveling in truth to materials, purity, harmony, and unity. Created over a fifty-year period, Leedy's art reflects its times. From realism to abstract expressionism, from pottery to clay sculpture, from clay to airborne nylon sculptures and on to outdoor murals and installations and performance art, the accomplishments of this sixty-nine-year-old artist have both anticipated and responded to many contemporary art trends. Nor is his an art easy to categorize, for Jim Leedy has truly been an artist who has crossed boundaries. He has chosen not to follow all the rules, even though he has been a teacher at the Kansas City Art Institute since 1966. In fact, his open-ended attitude and refusal to court closure have been the keys to his success as a professor of art. Encouraging students, allowing them to go anywhere and try anything, he has been partly responsible for the flourishing of other artists, who in turn have spread a gospel of experimentalism through various parts of the United States and in Scandinavia and Asia as well. At the same time, Leedy's awareness of collage, assemblage, and the use of found objects has led to a group of extraordinary works that treat American myths of patriotism, war, childhood, and violence, among other themes.

How a young man brought up in Kentucky, Virginia, and Montana, with roots deep in rural America, became an artist, art historian, curator,

Jim Leedy as a sophomore at Richlands High School, Richlands, Virginia, 1946.

and art dealer of highly sophisticated sensibility is a complex and lengthy story that has been reviewed and rehearsed many times by many other writers.[1, 2, 3] Here, it is Leedy's multifarious studio activities that concern us: how a boy who grew up near a clay pit and brick factory became so comfortable with clay that he could make it do anything. More than that, we will explore the evolution of a painter who was present in New York at the dawn of abstract expressionism, and who became the first American to adapt the New York School's spontaneity, chance, and chromatic felicity to ceramics as well as to painting. Add to those accomplishments Leedy's persistent loyalty to the human figure, and an entire dimension of narrative, portraiture, and expressive content emerges.

Crossing boundaries, breaking rules, drawing inspiration from deep stores of subjective feeling—these are qualities that many modern artists have cultivated. And Leedy, in one way, is the archetypal modernist, poised at midcentury, when his artistic career began. But because he never fully rejected representation, and because he often worked at the fringes of the American art scene in the Midwest after 1958, when he left New York, Leedy's journey

as an artist has involved other issues, which today may be seen as postmodern. For example, his interest in the margins of art (an interest expressed through his work in ceramics) and his use of fragments and unexpected materials also place him in the stream of postmodernism. Explicit social content (in the form of antiwar themes and attacks on religion) and Leedy's hidden history as a photojournalist are two other crucial keys to understanding his art in its broadest sense. Here is an artist who has progressed in streams, threads of ideas, strings of thought, and swaths of studio production, and this volume, by considering the breadth and depth

Near Pork Chop Hill, Korea, 1951.

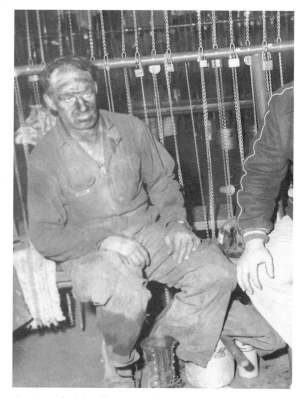

Survivor of mining disaster, Pocahontas, Virginia, ca. 1950.

of his achievements as a whole, offers readers a total apprehension of his work that no single exhibition or retrospective survey has ever encompassed.

Before we embark on our recapitulation of Leedy's odyssey, let us examine what few uniting themes there are, broadly general though they may be. On one overarching level there are visual themes of fragmentation, discontinuity, and chaos. On another, underpinning level there are repeated images of growth, evolution, and an expanding universe. Nearly Whitmanesque in his embrace of opposites, Leedy the creative wizard has brought all these themes together in a lifetime of intensive studio work.

Two aspects of Leedy's background—his work as a photojournalist for the U.S. Army in the Korean War, and his unapologetic acceptance of craft, as in his use of such traditional materials as clay, wood, glass, metal, and cloth—help explain what followed. Unlike other American artists of his generation, Leedy found his youthful optimism significantly tempered by a tour of duty in Korea (1951–1952). Images of destruction and death appeared in his art for decades afterward, and there they have continued to appear right up to the present.

In his brief work as a photojournalist after the Korean conflict, Leedy also encountered disasters in civilian life: a coal-mining tragedy in Virginia and, later on, while he was a graduate student, a tornado in Carbondale, Illinois. These jolting encounters stayed with him, coloring his vision as a painter and allowing him to adapt, with some level of comfort, to such ultimately uncontrollable forces of nature as the fire that, though contained, still roars in a kiln.

Among all American painters, Leedy is the only eyewitness to the postwar New York School to have ventured successfully into ceramics for such a long and fruitful period. With his roots in the South, he developed his affinity to the crafts through firsthand experience. His exposure to the handmade occurred right at home, and once he had been introduced to examples of another handmade art—painting—in the downtown studios

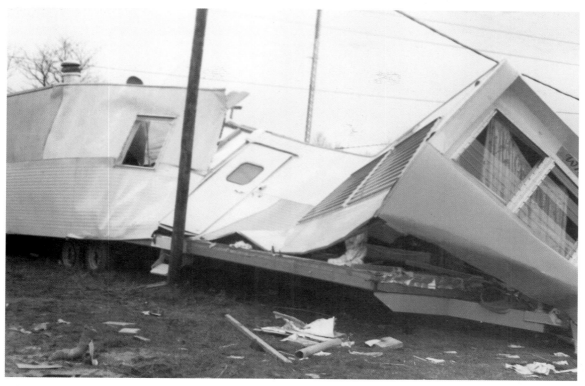

Aftermath of tornado, Carbondale, Illinois, 1957.

of New York, as early as 1950, Leedy recognized that material mastery could lead to expressive breakthroughs of the highest order. Simply put, if a painting could be treated like a pot's surface, onto which things other than colored pigment could be added, then this meant that a pot's surface could also be treated like a canvas. Pot and painting, both of them spattered, dripped on, and caked, received equal attention.

In addition to the work's opposite poles of optimism/exuberance and construction/destruction, another aspect of Leedy's art, often overlooked, is worth mentioning: a strain of Christian symbolism (though he abandoned it early on) that provides a generating motive for several of the early works. As we shall see, the cosmic aftermath, or afterlife and transcendence, has served as a theme for some of Leedy's most recent large-scale abstract paintings. What happened in between the early Christian symbolism and the later large-scale abstract paintings was Leedy's exposure to Taoism and Zen Buddhism. Life forces present in nature may contain powers both destructive and positive, but Leedy, in his studio activities, has synthesized

these principles so that, in an abstract context, they offer indirect hints at the coexistence of a life-affirming optimism with dread and doom.

Leedy may have been a fellow traveler in the world of New York School painting, even adding clay fragments to the surfaces of his canvases in the early 1950s, but there is no question of his innovative leadership in American ceramics. His breakthroughs in 1953 were a result of two forces: his exposure to the spontaneity and subjectivity of abstract expressionism, and his parallel studies at Columbia University, in European art and Asian art history. Thus, whereas recent authors have stressed roots in Japanese ceramics with respect to the art of Leedy's friend Peter Voulkos (b. 1924),[4] Leedy's influences have included classical Chinese bronzes and ceramics in addition to Japanese models. His summer graduate studies at Columbia, with James Marston Fitch and Meyer Schapiro, introduced him to both Western and Eastern traditions and, together with his hundreds of hours spent in the galleries of the Metropolitan Museum of Art, prepared him for a cultured yet radical response to the art of the day.

3

Shaped Painting, *1955. Oil on canvas, 40 x 60 x 24. Private collection, San Diego, California.*

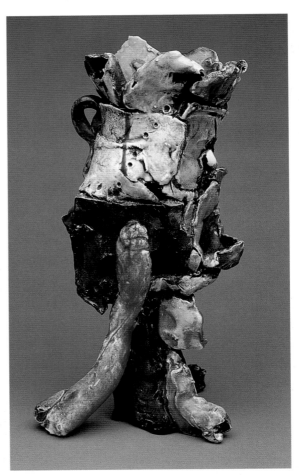

Abstract Expressionist Shang II, *1953. Low-fired stoneware with resin glaze, 14 x 8.*

As for Leedy's influences, two exceptional personalities whom he encountered at the Cedar and Dillon bars, Willem de Kooning (1904–1997) and Franz Kline (1910–1962), had highly significant impacts on Leedy. Because his approach to the avant-garde was a learned one, however, it continued to evolve after he left New York and Columbia to pursue further graduate studies in art history, at Ohio State University and Michigan State University. Additional graduate studio work in painting and sculpture at Southern Illinois University brought him into contact with R. Buckminster Fuller (1895–1983), the revolutionary thinker who, years later, was a belated influence on Leedy's adventurous nylon sculptures. Leedy, like Fuller, both accepts gravity and fights with it.

Leedy's widespread touring of the United States, Europe, and Asia belongs to a unique development in American craft history: the demonstration workshop. As Leedy built works on site with students, often leaving these works behind, his production mushroomed. Along with such demonstrations, Leedy's lectures brought out another influence from his past: that of the Southern preacher. In his talks, like an itinerant evangelist or midwestern rainmaker, Leedy spread the experimental ideology of modernism. Moreover, because he is one of the few American ceramists with a firm claim to being an intellectual, Leedy's lectures informally crossed boundaries, moving from a strict glaze-formula mentality to an analytical challenge with respect to the limitless potential of all art

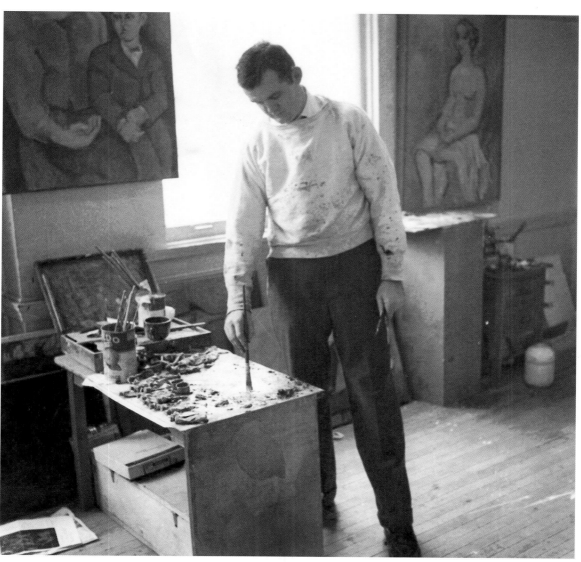

*Artist in studio, Southern Illinois University, Carbondale, 1957 (**Seated Female,** 1952, at right in background).*

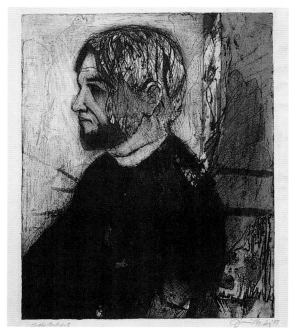

Self-Portrait, *1954. Drypoint etching, 22¼ x 17½.*

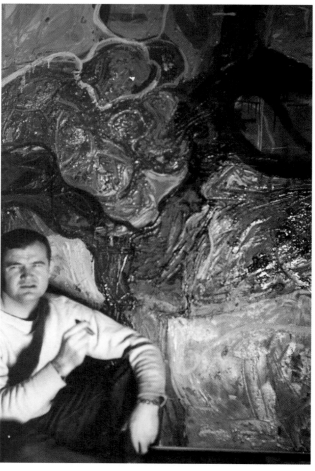

Artist with **Abstract Cross** *(1955) in New York, 1955.*

materials—and nonart materials. What was taught in the demonstration workshops, and what has been taught in Leedy's classes at the Kansas City Art Institute, is learning by example. Leedy has brought his own art right into the classroom, glossed it with running commentary, and communicated his enthusiasm and knowledge to generations of art students. He has combined compassionate encouragement and freedom from polemics with a grasp of the fundamental changes that American art has undergone since 1945.

Leedy did choose sides, but he has been canny enough to leave all his options open. If he neglected representation in favor of modernist abstraction, it was never for long; and clay, as a sculptural vehicle, now stands equal for Leedy to bronze, wood, and found objects. Leaping forward and often doubling back, Leedy has not so much made frequent changes of style as adapted external influences—artistic, social, political—to his already fully evolved sensibility. The movements of this labyrinthine journey have been sometimes tempestuous, sometimes delicate. As we consider the separate stages of Leedy's journey, from paintings to ceramics to sculptures to the works of the present, we may find it possible to bring the artist's various undertakings together and reweave the tapestry of his art into a coherent, perceptible whole.

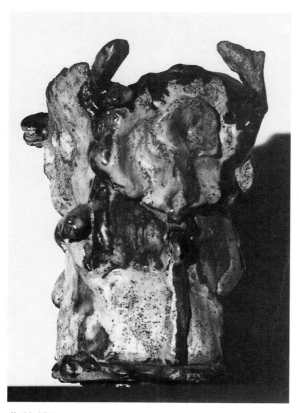

Untitled Pot, *1960. Stoneware, 12 x 4 x 4.*

7

PAINTINGS

Given the interest often shown in his ceramics, Jim Leedy's role as a colorist has been overlooked. But long before he was a potter or a ceramic sculptor, Leedy was a painter. Indeed, from his earliest mature painting (*Seated Female*, 1952) to his latest large-scale diptychs (*Creation*, 1995; *Expansion*, 1996), Leedy has had a love affair with paint and its chromatic potential.

Seated Female may have been painted under pressure from a classroom teacher while Leedy was enrolled in the Richmond Professional Institute at the College of William and Mary, but it still exudes a serene confidence. Indeed, after the exciting experiences of the Korean War, this twenty-two-year-old student was not content merely to remain in Virginia, studying on the G.I. Bill. He made frequent weekend trips to New York to see gallery and museum exhibitions and keep up with newfound friends. Early New York School artists like Franz Kline and Willem de Kooning occasionally exhibited at the Sidney Janis and Charles Egan galleries, and Leedy was also able to imbibe a heady urban atmosphere at the bars all these artists frequented.

Seated Figure (1955) shows the influence of de Kooning's *Woman* paintings, which Leedy had seen the year before. Forsaking naturalistic color, Leedy made his own new woman a construction of paint, a recoding of the figure through pose and pigment. Set against a fiery red background, like de Kooning's *Woman IV* (1952–1953), *Seated Figure* also rejects individualized portraiture—something to which Leedy, years later in Kansas City, would return with a vengeance.

Ironically, a woman was also the source of the younger artist's fabled barroom brawl with de Kooning.[1] When Leedy chatted up a young woman who happened to be a former girlfriend of the forty-nine-year-old Dutchman, de Kooning taunted him. Leedy returned the older artist's taunt and, once they began to fight, promptly flattened him. As was common in the macho milieu of the time, the two then became warm acquaintances, if not exactly drinking buddies. It is true that Leedy was only one

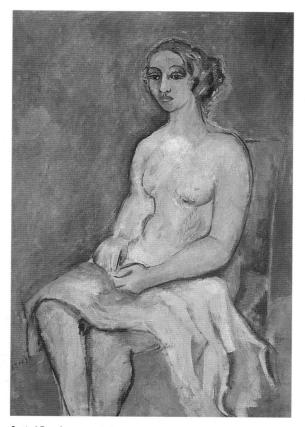

Seated Female, *1952. Oil on canvas, 40½ x 28½.*

9

Seated Figure, *1955. Oil on canvas, 68 x 58.*

Female Figure, *1955. Pastel on paper, 24 x 18.*

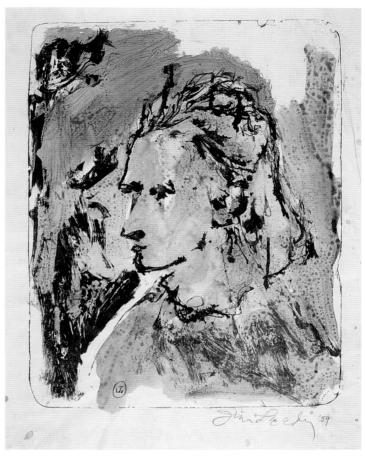

Woman, *1954. Hand-colored lithograph, 18 x 14.*

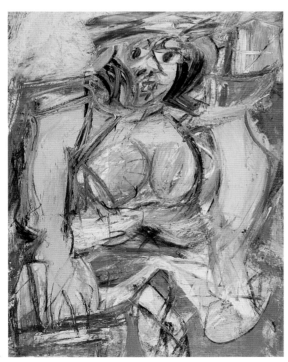

Willem de Kooning *(1904–1997),* **Woman IV,** *1952–1953. Oil, enamel, and charcoal on canvas, 59 x 46¼. The Nelson-Atkins Museum of Art, Kansas City, Missouri. Gift of William Inge.*

Artist in New York, summer 1957.

among a great many younger downtown artists of the period who admired de Kooning, but it is no less true that the immigrant artist's fusion of abstraction and figuration would remain a shining beacon for Leedy in the decades to come.

Leedy saw Jackson Pollock (1912–1956), although he never met him, but the Wyoming-born artist's radical brush techniques nevertheless influenced the younger man's painterly attack. *Untitled* (1954) found Leedy still painting on the easel but now emphasizing process through drips around white- and black-outlined curved forms. Structure always remained more important for Leedy than for Pollock, but in 1955, the year after this first experi-

ment, Leedy was not only tilting and dripping on canvases but also rejecting the rectangle.

Leedy's two *Shaped Paintings* (1955; see also p. 4), each one juxtaposing trapezoidal and rhomboidal stretchers within a single work, anticipate by nine years the shaped canvases of Frank Stella (b. 1936)—for example, Stella's *Quathlamba*, from 1964. With surfaces of pooled and spattered paint, Leedy was moving away from outlined circles and toward a picture plane that was itself the defining form.

Falling (1957), painted during the first full summer that Leedy spent in Manhattan after leaving Richmond, exploits Pollock's innovations one year after the artist's tragic death. The brown ground is an earthy foreshadowing of clay, but, more important, it acts as a contrasting foil to the black, white, orange, and red drips that dominate the image. *Controlled Happening* (1958), *Order in Disorder* (1959), and *Running Red* (1959) all retain Pollock's drips but restore clearly defined areas of color. As in the kiln-based firing process, Leedy was able to let chance play a part, up to a point, but he also sought to integrate forms,

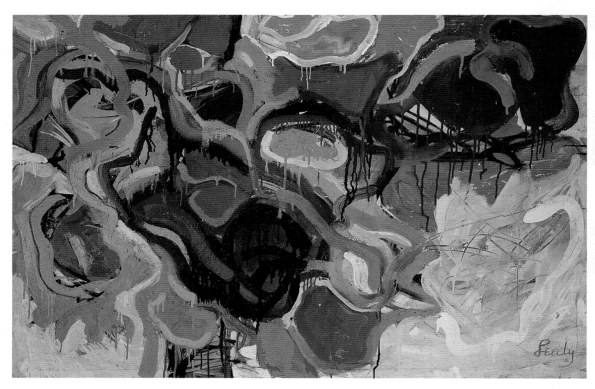

Untitled, *1954. Oil on canvas, 38 x 58.*

Shaped Painting, *1955. Oil and cloth on canvas, 54 x 61.*

Falling, *1957. Oil on canvas, 69 x 55.*

Controlled Happening, *1958. Oil and cloth on canvas, 61 x 71.*

Running Red, *1959. Oil on canvas, 68 x 63.*

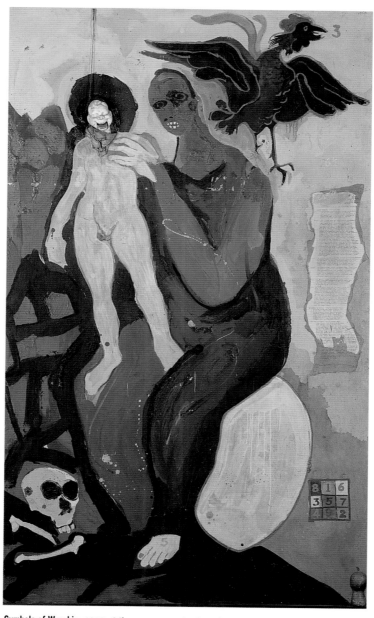

Symbols of Worship, *1958. Oil on canvas, mixed media, 71 x 46.*

Rising Spirits, *1957. Color intaglio print on paper, 17½ x 17½.*

system, and plan into the environment of the acted-upon canvas. He rejected Pollock's centerless, "all over" composition in favor of an interplay between seemingly improvised areas and more clearly planned sections.

Not that Leedy was forsaking the figure: works like *Symbols of Worship* (1958), *Rising* (1959), and *The Annunciation* (1961; formerly *Birth*) are multiple-figure groups that radically reinterpret religious subjects. For example, in *Symbols of Worship*, heretical by comparison with a strict depiction of Christian images, the head of the infant Christ is replaced with a white-painted Howdy Doody head, and collaged-on texts appear below a rooster, which parodies the Holy Spirit as dove but also symbolizes Christ's prediction of Peter's denial at the triple crowing of the cock. A skull and crossbones nestles at the feet of the madonna, echoing the skull at the

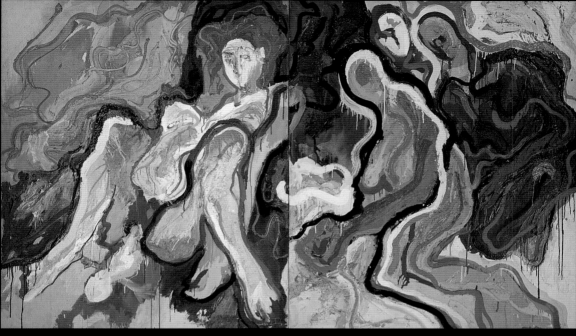

The Annunciation, *1961. Oil on canvas diptych, 60 x 102.*

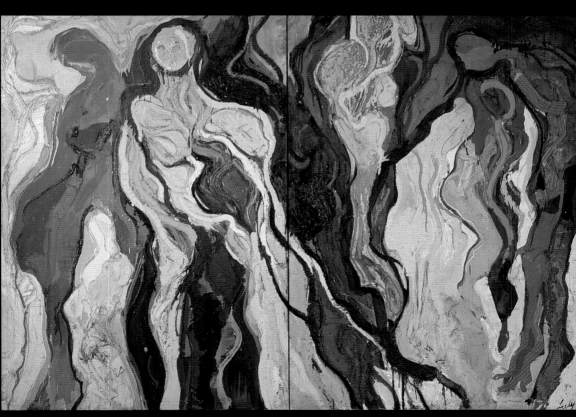

Rising, *1959. Oil on canvas diptych, 68 x 96.*

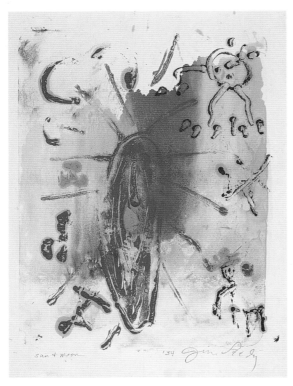

Sun and Moon, *1954. Monotype on paper, 17½ x 12½.*

foot of the cross, which itself symbolizes Adam and implies that Christ died for everyone's sins, even the first man's.

The Annunciation, more painterly and less preachy, was created shortly after Leedy arrived in Missoula, Montana, to accept a teaching post at the University of Montana. This exuberant diptych of a woman giving birth, with three shadowy figures in attendance, was censored in Leedy's own campus studio after a complete stranger wandered in and filed a complaint with the dean.

Leedy soon decided to seek a position elsewhere, but not before having brought the gospel of abstract expressionism to the isolated university town. For example, Leedy's impact on his colleague Rudy Autio (b. 1926) was considerable. Autio, who admits that he had seen no work by abstract expressionists in person until his 1962 visit to the Seattle World's Fair,[2] later wrote the catalog essay[3] for Leedy's 1968 one-man show at the Museum of Contemporary Crafts, in New York. Leedy's paintings during the University of Montana period also anticipate the generalized female figures that

would later turn up on the surfaces of Autio's hand-built slab pots.

At the time of Leedy's first solo show in New York, which took place at the Art Directions Gallery in 1963, he was still at the University of Montana. By the time of his second New York solo show, at the Madison Gallery[4] in 1964, he had left conservative Montana behind, and by the time of his third, at the Panoras Gallery in 1966, he had already spent two years as an art historian at Ohio University and moved on to the Kansas City Art Institute. Leedy would have a second solo show at the Panoras Gallery, in 1967; his first Panoras show included mostly figurative works, among them *Rising*, another vaguely blasphemous depiction, this one of Judgment Day and the multitudes' ascension to heaven. In *Rising*, the ghostlike male and female figures are securely fused to the flat picture plane, existing without perspective or background space.

Leedy's happy move to Kansas City and its comparatively cultured atmosphere coincided with his shift to the more open, lighter pictorial space found in a series of ethereal paintings whose basis is formed by an exquisitely nuanced, neutral ground. In these works—possibly influenced by color-field painting but much more physically engaged, with their random interpolation of colored clay fragments—Leedy was once again crossing boundaries. *Behind the Sun* (1969), for example, and *Floating Fragments* (1959–1969) pick up threads that Leedy had set aside in the late 1950s. *Behind the Sun*, closer to Pollock's centerless compositions, is anchored by a red disk, itself foreshadowed by a 1954 monotype, *Sun and Moon*. Both *Behind the Sun* and *Floating Fragments* also mark the shift to a more "feminine" palette, with pale lavenders, greens, blues, and yellows. Another canvas from this general period, *Untitled* (1970), seems to foreshadow the work of such young abstract painters of the 1990s as Jonathan Lasker. A square painting with irregular organic forms sharply outlined in color, *Untitled* employs bright sensual colors in interlocking X forms that never resort to system or pattern.

Behind the Sun, *1969. Oil on canvas with clay additions, 48 x 51.*

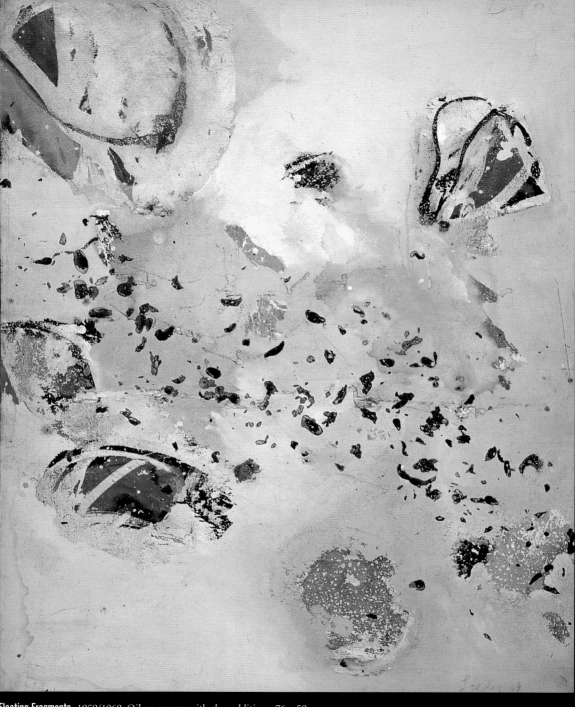

Floating Fragments, *1959/1969. Oil on canvas with clay additions, 76 x 59.*

Untitled, *1970. Oil on canvas, 60 x 60.*

Leedy's shift, in the 1980s, to painting with oil and acrylic on paper and canvas opened a whole new world for explorations of color, brush attack, and subject matter. With the figure represented by the color pink (as was true for de Kooning, too, after he moved to Long Island), Leedy undertook a series of large-scale paintings, some more than ten feet wide. *Continental Expansion* (1980), for example, pushes beyond the canvas edge with intrusions of green and sections of bright orange that resemble patches of glaze.

Conflicts and divisions frequently characterize the composition of the paintings from the 1980s and 1990s as various areas erupt in volcanic activity.

Painted on the floor, these works reopen Leedy's dialogue with Pollock, twenty years later. Kline, another occasional cohort from the Dillon Bar, is also honored or alluded to in works like *Big X* (1987). (The X shape, of course, also became a signature mark in Peter Voulkos's torn plates of the late 1970s.) Whereas Kline's intersecting black marks—for example, in *Turin* (1960)—make the surrounding white spaces charge forward, in Leedy's *Big X* and in the 1996 work *Expansion* they mark out territorial space within each painting's composition.

Nothing less than the expansion of the universe is one underlying theme of the big paintings of the middle to late 1990s, but these are also the

21

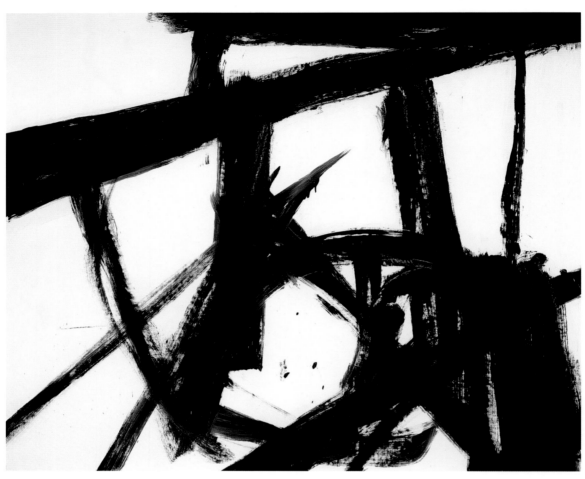

Franz Kline *(1910–1962),* Turin, *1960. Oil on canvas, 80⅜ x 95½. The Nelson-Atkins Museum of Art, Kansas City, Missouri. Gift of Mrs. Alfred B. Clark through the Friends of Art.*

artist's most abstract and purely painterly works to date. *Vision* (1989) and *Expanding Forces* (1993) set up chromatic contrasts that suggest the deep space of exploding galaxies and churning gases. Heavily materialized in the deft use of oil and acrylic, these works reveal pictorial space in ways that were unthinkable in the earthy canvases of Leedy's New York years. (Caught in midcontinent, the artist also lives near an earthquake fault line in Missouri.) The night-blue sky of *Vision* is peppered with slashes of red, and nearby these slashes is a somnolent symbol of humanity and culture: a collaged-on reproduction of the *Mona Lisa* that may also symbolize the ultimate work of art or may stand in for all art.

Expanding Forces, the 1995 work *Creation,* and *Expansion,* from 1996, are all anticipated by a crucial early work, *Life Source* (1958). One of Leedy's most sublime paintings, *Life Source*, with its limited palette of red and pink, and its quietly swirling

areas evocative of the primordial soup of earth's first organisms, comes closest among all Leedy's paintings to being a centerless composition. The half-and-half division of *Life Source*'s surface sets the stage, however, for the 1990s and Leedy's extrapolations of conflict and expansion. *Expanding Forces* recalls Japanese sumi brushwork, something Leedy is much closer to understanding than was Kline, to whom it was nevertheless repeatedly imputed. The paint, highly liquid, advances toward the center from each corner. This work, with its rising lower mound (or "tidal pool"), is a virtual tryout for the later masterpieces *Creation* and *Expansion.*

The light-to-dark division of *Creation* can be seen as a latter-day addendum to the religious themes of the 1950s. Not that the painting is in any way narrative: it shows Leedy at a peak of his painterly powers, invoking his imprinted allegiance to abstract expressionism, but with a lifetime of

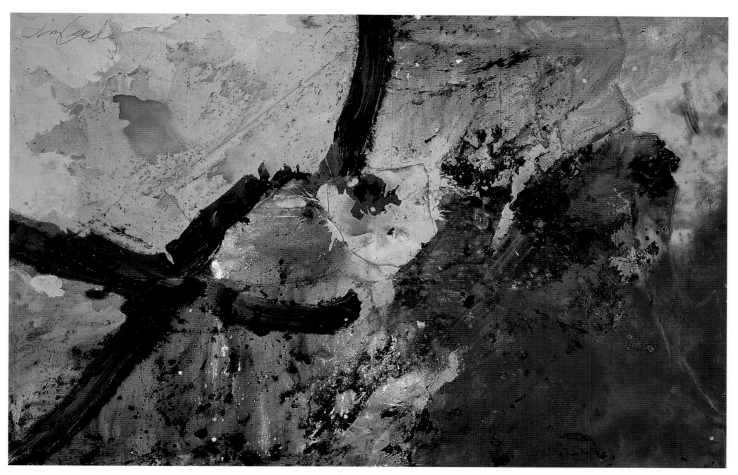

Big X, *1987. Oil and acrylic on paper mounted on wood, 47 x 72.*

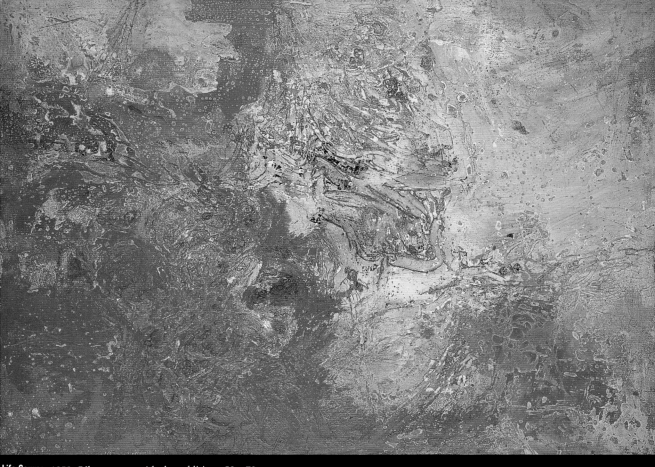

Life Source, *1958. Oil on canvas with clay additions, 50 x 70.*

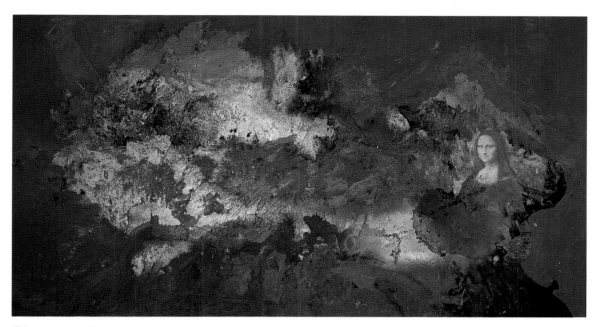

Vision, *1989. Acrylic and oil on canvas, 66 x 120.*

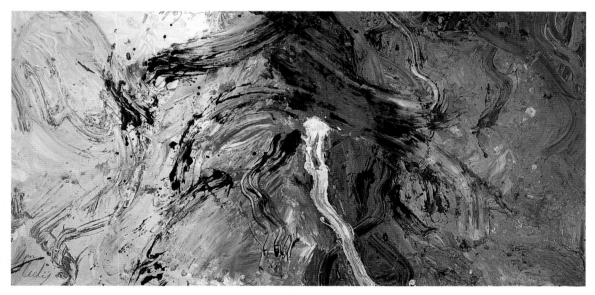

Creation, *1995. Acrylic on paper mounted on wood, 48 x 97.*

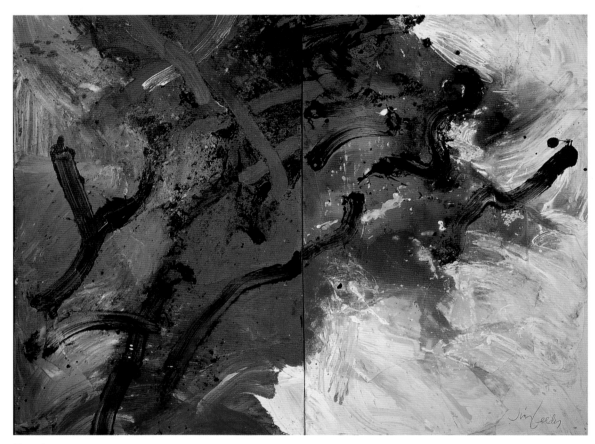

Expansion, *1996. Oil and acrylic diptych with paper on canvas, 73½ x 94½.*

artistic exploration and mastery over materials. The large, central V shape is a vaginalike opening, not very different from the more explicit images of *The Annunciation*. The central part of *Creation*, an arena of turbulence, is punctuated by a broad white line ending in the exact center, as if to show divine intervention—or a spermatozoon—also present at the creation of the universe.

The conception of a male child in the collision of X and Y chromosomes seems the possible symbolic subject of *Expansion*. With central red blood-like masses in another womblike configuration, the floating X and Y shapes struggle to merge in an extraordinary vision of conflict, color, and paint. Such letter motifs had occurred earlier, in *Big X* and *XY* (1962), but here they achieve an apotheosis that combines vigorous painterly attack and carefully modulated areas of contrasting color. Leedy's vision of expansion is one of primal origin, a vision both tragic and timeless and, in this way, tied to abstract expressionism but also, like all Leedy's best paintings, highly autonomous and original.

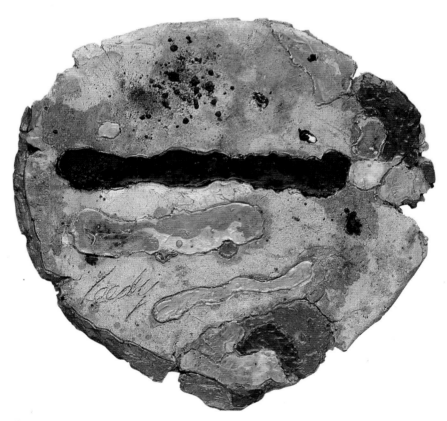

Storm Cloud, *1991. Stoneware and glazes, 20 x 19 x 3.*

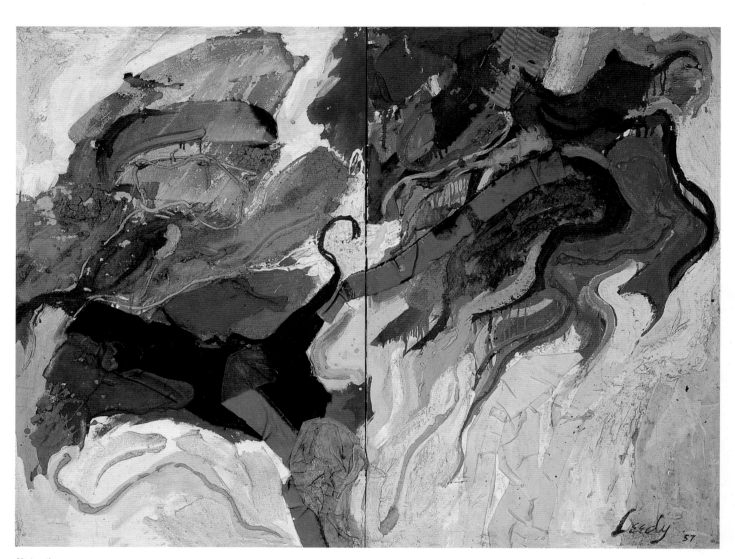

Abstraction, *1955. Oil and cloth on canvas diptych, 50 x 68.*

Untitled, *1958. Oil on canvas, 51 x 48.*

Silent Fear, *1959. Oil on canvas, 69 x 53.*

Christ, *1954. Oil on canvas, 48 x 38.*

32

Continental Expansion, *1980. Oil and acrylic with paper on canvas, 30¾ x 40.*

(right) Big Bang Detail *(detail), 1956. Oil on canvas, 65 x 68.*

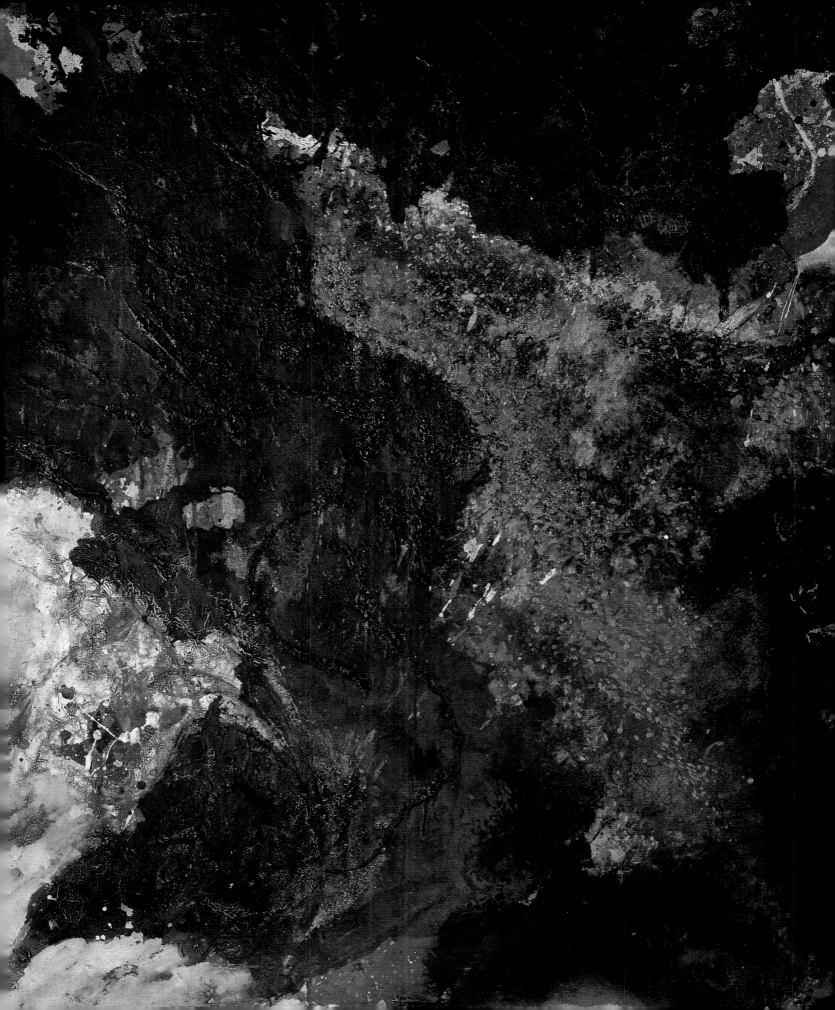

Forming, *1971. Oil on canvas with clay additions, 54 x 69.*

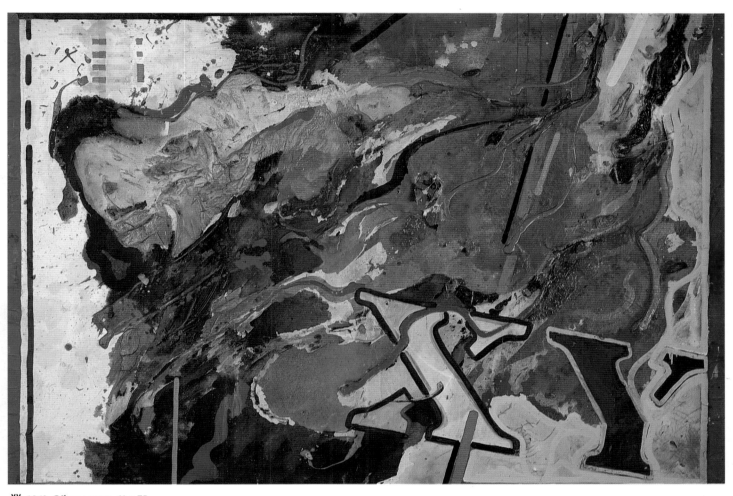

XY, *1962. Oil on canvas, 61 x 75.*

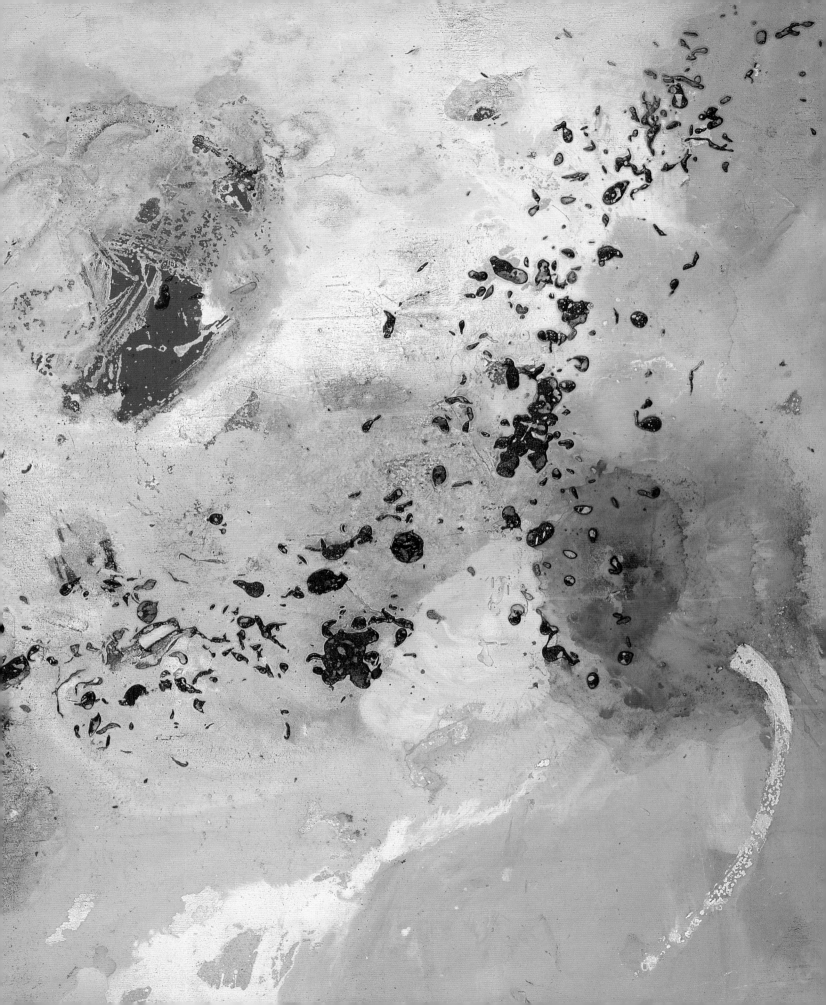

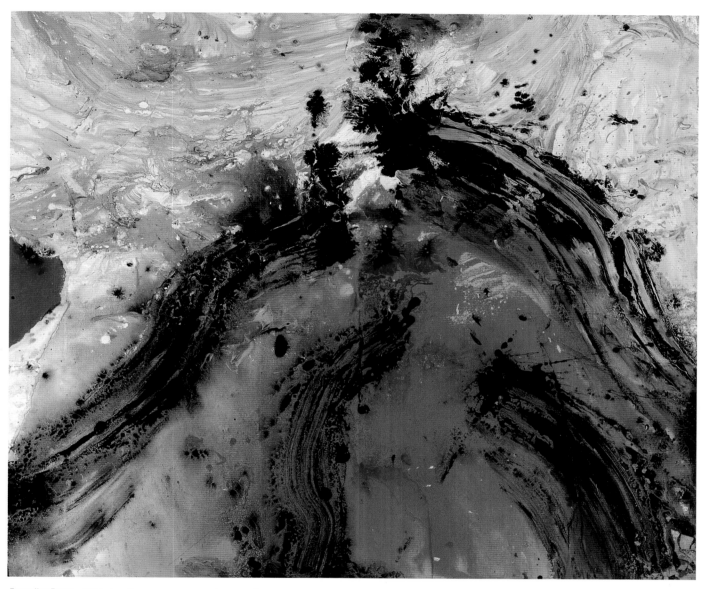

Expanding Forces, *1993. Acrylic on paper mounted on wood, 37 x 44¼.*

(left) Cosmic Detail *(detail), 1972. Oil on canvas with clay additions, 58 x 69.*

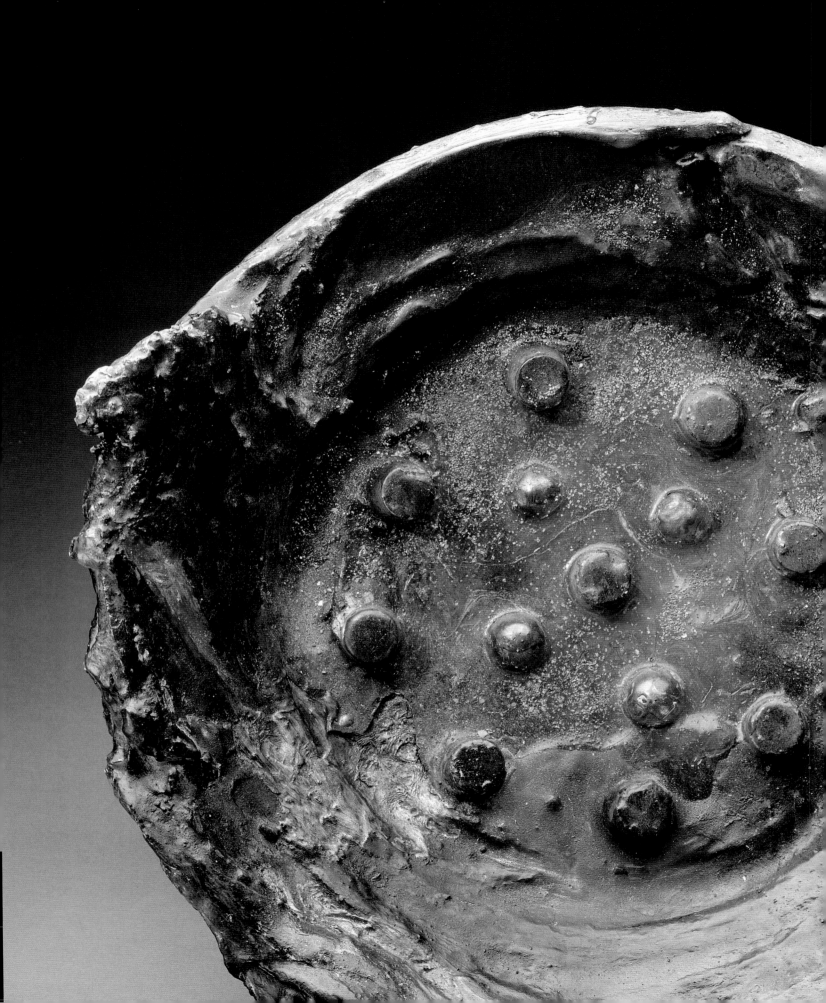

"I Am Clay"

CERAMIC PLATES AND VESSELS

Jim Leedy's contributions to American ceramics are substantial. His innovative firing techniques of the late 1940s—when he tried, as an adolescent, to emulate an African stacking kiln in his Virginia backyard and inadvertently made the equivalent of Japanese raku—have been widely chronicled.[1] He was like the character in the Molière comedy *Le Bourgeois Gentilhomme* (1670) who is delighted to learn that he has been speaking prose all his life: only later did Leedy learn that he had been a raku-revival pioneer.

His use of a blowtorch to bond polyester resin chips onto clay tripod vessels brought about an unprecedented blend of traditional and industrial materials, and his incorporation, in 1953, of loose abstract expressionist construction and improvisatory painting techniques into his plates and vessels can now clearly be seen as the first application of abstract expressionist principles to ceramics. This advance apparently remained unknown as late as 1961, however: Rose Slivka does not credit Leedy with it in her canonical *Craft Horizons* essay of that year, even though very few of the people discussed in her article shared Leedy's bright, vivid, painterly use of color.[2]

As already mentioned (see the Introduction, p. 1), Leedy's identification with his material, clay, may date back to his early childhood and his having grown up in Richlands, Virginia, near a clay pit and brick factory. As he told a group of students in Bergen, Norway, "I am clay."[3] (This statement was an ironic echo of Jackson Pollock's reply to Hans

Hofmann when Hofmann told him to study nature: "I am nature.") Leedy has also long told his students the story of his mother's craving to consume clay while she was pregnant with him. All of this may explain why Leedy's ceramics often look so unfinished, loose, and raw: they are evoking clay in its natural unfired state. Later on, fire would become for Leedy a tool in its own right, collaborating with Leedy in various ways, controlled but ultimately uncontrollable.

In LaMar Harrington's seminal 1979 study,[4] Jim

Artist with blowtorch, 1964.

opposite page:
Expressionist Plate (detail), 1954. Stoneware with raku glazes, resins, and beach glass, 19 x 17 x 6. Donna Schneier collection, New York.

Bentware Covered Jar, *1954. Raku clay with resin glazes, 14 x 10 x 7.*

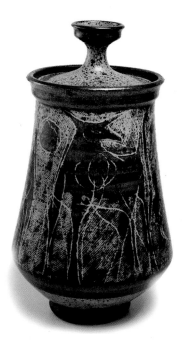

Peter Voulkos *(b. 1924),* **Covered Jar,** *1953. Stoneware, white slip, red iron slip. Wheel-thrown; sgraffito drawing through wax resist, 17 x 9 diam. Collection American Craft Museum, New York. Gift of Aileen Osborn Webb, 1967. Donated to the American Craft Museum by the American Craft Council, 1990. 1967.21a,b.*

Leedy is rightly grouped with Rudy Autio and the artist Peter Voulkos as belonging to the Montana clay revolution of the 1960s, and yet Leedy was already a revolutionary ceramist before he arrived in Missoula, in 1959. His breakthroughs in firing, materials, and color revolve around the *Visualware* and *Bentware* series (1953–1957; Leedy invented these two terms to explain his various reasons for breaking the sacred rules of function).

These two series, which coincide with Leedy's studies at Columbia University of ancient Chinese bronzes, share triple-strut bases with their Chinese models. Like the bronzes, Leedy's *Abstract Expressionist Shang I, Abstract Expressionist Shang II* (see p. 4), and *Untitled Stilted Vessel* (all from 1953) and *Bentware Covered Jar* (1954) are less for practical use than for ceremonial contemplation. Leedy was scrutinizing art history for examples of function replaced by sculptural status, and at the time he may have been the only ceramic artist in America with such advanced ideas: the California Funk movement would not occur until the early 1960s.[5]

The intensity of color in the *Shangs* and other works from this period is a result of what Leedy called "resin glaze"; that is, it was the outcome of his using a blowtorch to bond scraps of colored

plastic resin to the clay surface. It was a dangerous experiment, however, and its highly toxic fumes eventually led the twenty-three-year-old artist to abandon this practice. The crude, shriveled appearance of these works, due to the jury-rigged pit-firing apparatus that would later be identified with Leedy's youthful experiments in raku, was a radical departure from the pristine, well-mannered pottery of the day. Once again, then, we see that Leedy's

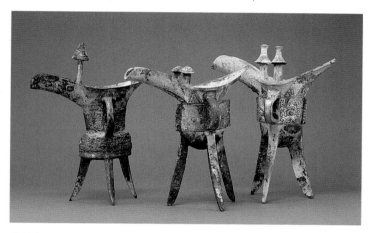

(left) **Chinese bronze,** *9⅛ x 6¾. Seattle Art Museum. Gift of Mr. and Mrs. Herbert Brink. 62.101.*

(center) **Chinese bronze,** *7⅞ x 7. Seattle Art Museum. Eugene Fuller Memorial Collection. 34.63.*

(right) **Chinese Jue bronze,** *late 12th century B.C.E–mid-11th century B.C.E. 9⁵⁄₁₆ x 7⅜ x 4⁷⁄₁₆. Seattle Art Museum. Eugene Fuller Memorial Collection. 49.200.*

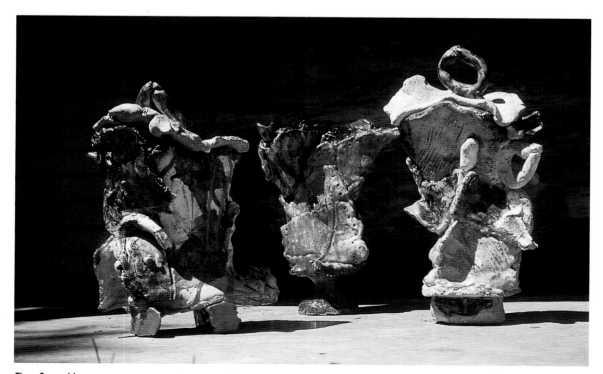

Three Covered Jars, *1960. Stoneware with glazes and resins, various sizes.*

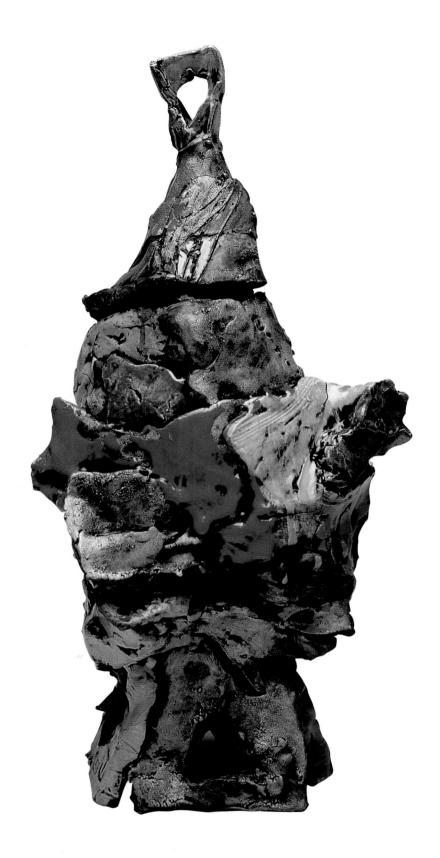

Slab Vessel, *1953. Handbuilt ceramic with resin glaze, 18 x 8½ diam.*
The Minneapolis Institute of Arts. The Ethel Morrison Vanderlip Fund.
91.139a,b.

Ceramic Plates and Vessels

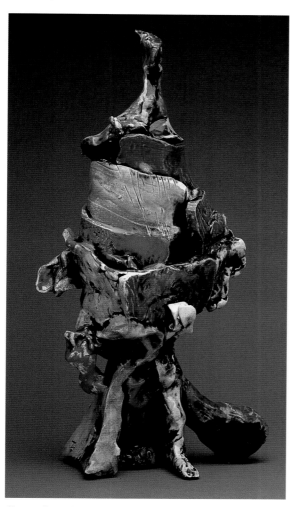

Abstract Expressionist Shang I, *1953. Low-fired stoneware with resin glaze, 16 x 9.*

surrealism: a radical act that subverted traditional expectations in favor of appealing, if disconcerting, visual properties. *My Break* violates the sacred inner space of a cup, rendering the cup impossible to use. Set on a plinth that resembles a brick, the cup is literally elevated: to the status of sculpture, and above the simple clay brick that is its functional counterpart. The brick may also allude to the brick factory, near the artist's childhood home, where workers allowed him to take the clay toys and pots he had made and place them onto bricks in the coal-fired beehive kilns. *My Break,* moldy- and archaic-looking, summons up archaeological allusions of age and oxidized patina but actually points ahead to an impressive body of work that will treat functional objects (plates, bottles, bowls, vessels) as sculptural forms for contemplation.

Contemplation of a broken cup is analogous to the Japanese connoisseurship of teabowls. Leedy was fully familiar with this tradition, thanks to his studies of Asian art history and his tour of military duty in Korea and Japan, where he was able not only to visit museums but also to see many galleries, pot shops, and studios. By breaking the cup, Leedy aestheticized it into something that was valid on its own terms, and he made a firm break with the prevailing functional traditions that for so long had been dominating American ceramics.

ceramics of the 1953–1954 period stand as the first authentic examples of abstract expressionist ceramics, for Leedy was consciously trying to introduce aspects of abstract expressionist painting into his work with clay. Moreover, the reds, yellows, and blues in these works, apart from their abstract expressionist provenance, may have a further symbolic relevance: on one level, primary colors are used to express a basic, theoretical exploration of color; on another, they recall the colors of Tibetan devotional art and its association of particular religious overtones with each color.

My Break (1957) stands as a symbolic shattering of function. It is comparable, for American ceramics, to what *Object* (1936), the infamous fur-lined teacup by Méret Oppenheim (1913–1985), was for

During the 1930s, Leedy had lived with his family in Montana, and he enjoyed returning there. The youngest of the trio of artists who became friends in Montana, he was definitely the bearer of new ideas. Rose Slivka has described how M. C. Richards took Voulkos to New York for the first time in 1953, after the summer session at Black Mountain College,[6] but Leedy had been visiting the city since 1945. Leedy used to meet with Voulkos in the summers, when the older artist returned to Montana after teaching at the Los Angeles County Art Institute (now the Otis College of Art and Design). Although Leedy was impressed with Voulkos's exuberant energy, he brought an already developed sensibility, quite independent of Voulkos's, to his own Montana-period handbuilt vessels. If his work from

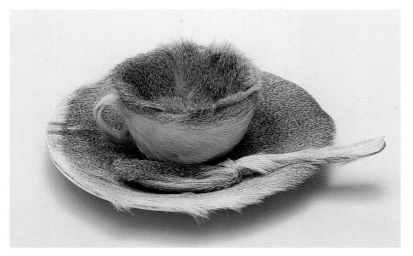

Méret Oppenheim *(1913–1985),* **Object (Le Déjeuner en fourrure),** *1936. Fur-covered cup, saucer, and spoon. Cup, 4⅜ diam.; saucer, 9⅜ diam.; spoon, 8 l.; 2⅞ h. overall. The Museum of Modern Art, New York. Purchase.© 2000, The Museum of Modern Art.*

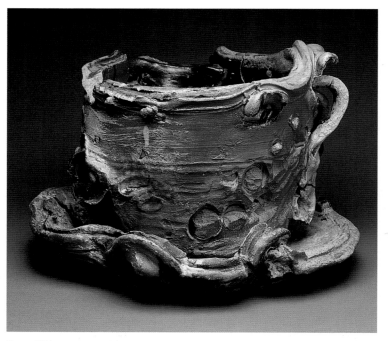

Cup and Saucer, *1999. Salt-fired stoneware, 13 x 20 x 20.*

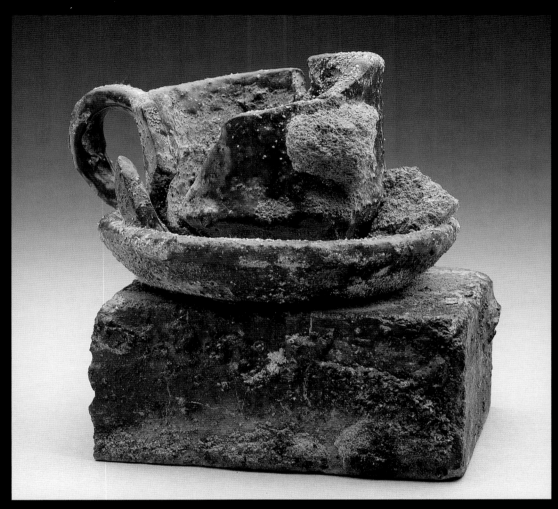

My Break (Bentware series), *1957. Stoneware, 7 x 7 x 6.*

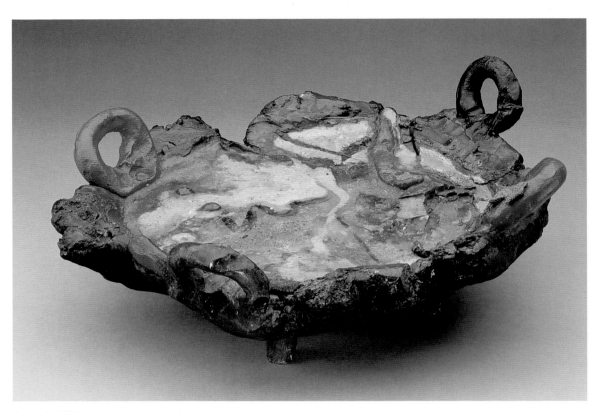

Expressionist Plate, *1955. Raku clay with resin glazes, 5 x 17 x 16.*

the 1980s and 1990s follows Voulkos's example of wood-fired torn and altered thrown plates, it should also be noted that Leedy is the one who encouraged Voulkos to try the *anagama*, or wood-fired kiln, as early as 1976.[7] Still, it may have been Autio's awkward combination of throwing and handbuilding and, later, simply handbuilding his "slab pots" that pushed Leedy toward his own unique contributions to the Montana ceramics revolution.

Works like *Expressionist Cup* (1960), *Untitled Pot* (1960), and *Kuke Jar* (1964) extend the advances of *My Break* into more and more sculpturally elaborate compositions. With space enclosed by lattices and loops, Leedy was redefining sculptural volume. *Stilted Vessel Sculpture* (1964) is a crucial transitional piece, right down to its title: vessel and sculpture. Over the centuries, means have constantly been sought for increasing the height of clay sculptures; in this piece, Leedy drew on examples from the second-century C.E. Eastern Han dynasty in China, adapting upright roof struts to this purpose. Here was a technical device—and visual motif—that would reappear countless times in the years to come.

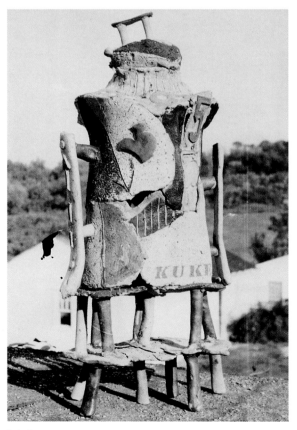

Kuke Jar, *1964. Stoneware, 20 x 12 x 6.*

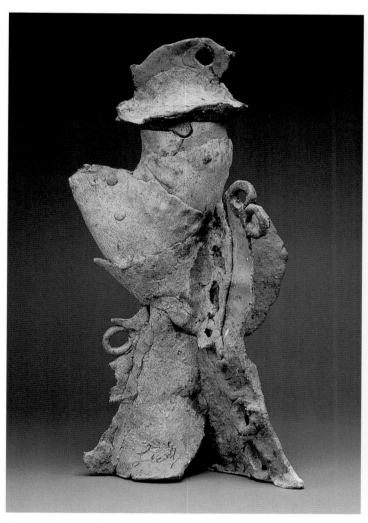

Baroque Vessel, *1964. Gas-fired stoneware, 20 x 10 x 10.*

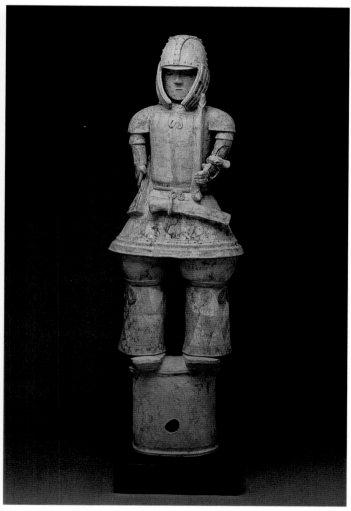

Japanese Haniwa warrior figure, *pottery, 6th–7th century* C.E.
Polychrome, 53¼ x 16½ x 10¾ diam. Seattle Art Museum.
Eugene Fuller Memorial Collection. 62.44

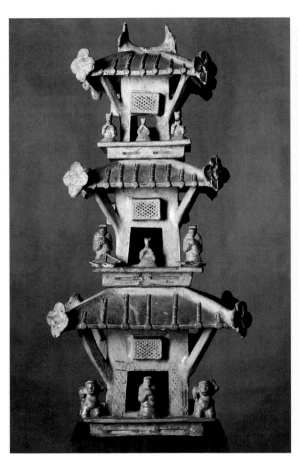

Chinese ceramic. *Three-storied watchtower, 2nd century* C.E. *Eastern Han dynasty (25–220* C.E.*). Earthenware with iridescent green glaze, 34½ x 14 x 15. The Nelson-Atkins Museum of Art, Kansas City, Missouri. Purchase: Nelson Trust.*

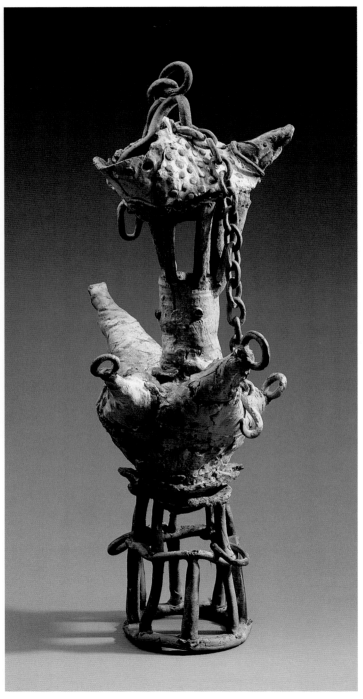

Stilted Vessel Sculpture, *1964. Stoneware, 41 x 26 x 17.*

Artist with first anagama *kiln, Athens, Ohio, 1965.*

After a brief stint teaching art history at Ohio University, Leedy arrived in Kansas City to take a job as an art historian and, later, as a professor of sculpture and an occasional department chair. His longtime colleague Dale Eldred (1933–1993) was a renowned sculptor of international stature. Their friendship had a profound impact on the program in sculpture at the Kansas City Art Institute, which graduated numerous outstanding artists. More significant, however, is that Leedy's new job apparently freed him to create an extraordinary series of tall, segmented vessel sculptures. Liberated from the oppressive, deserted cultural landscape of Montana, for the rest of the 1960s Leedy produced an enormous amount of innovative work in ceramics. His first museum show in New York, at the Museum of Contemporary Crafts, in 1968, was an exhibit of tall, large-scale sculptures, along with some stilted vessels and plates.

In the late 1970s, after a hiatus of nearly a decade during which he pursued nylon "sky art," Leedy returned seriously to clay. This time around, the plates and vessels, along with the abstract sculptures of clay, took on greater authority in terms of size, color, and ambition. The raku- and salt-fired plates and slabs were more controlled with respect to the expressive traces left on the bare clay surfaces by firing. Red and blue linear strokes reappeared, first realized with great success in *Expressionist Plate with Blue X* (1969) but also in *Plaque with Red Spots* (1985), *Expressionist Plate* (1986), and *Plate* (1988).

In *Plate 892* and *Plate 897* (both from 1989), even though these works are assertive examples of

chromatic application, the colors attain a delicate painterly presence seemingly at odds with the smoldering of the pit-firing process. By this time Leedy had also dropped his previous practice of using scraps of plastic to add color to clay: it was no longer necessary to apply color with a blowtorch!

With *Stilted Vessel Sculpture* as a precursor of sorts, much of Leedy's ceramic work of the 1970s and 1980s concentrated on figurative sculptures of ever-increasing height. But the plates and vessels incorporated occasional figurative elements, too, using life-cast clay masks of Leedy's friends and

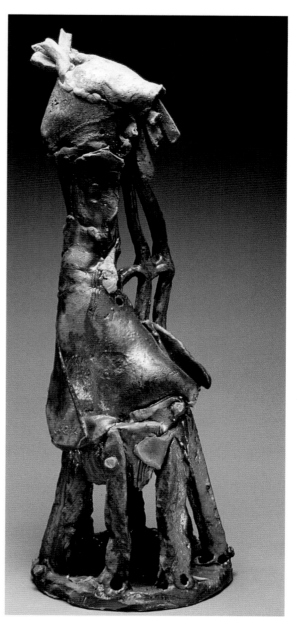

Vessel with Cap, *1990. Wood-fired stoneware, 39 x 14 x 14. Snite Museum, University of Notre Dame, South Bend, Indiana.*

49

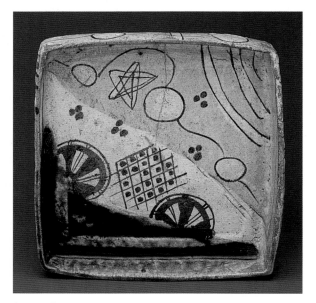

Japanese tray, *early 17th century, Momoyama period (1568–1615). Mino ware, Oribe type; stoneware with green and transparent glazes over painted decoration in iron oxide, 8 x 7¾. Seattle Art Museum. Eugene Fuller Memorial Collection. 56.130.*

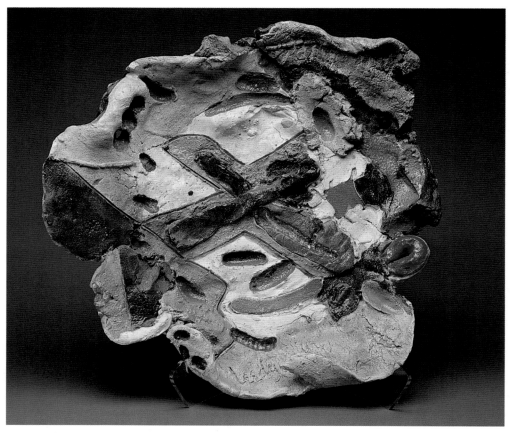

Expressionist Plate with Blue X, *1969. Stoneware with engobes, 21 x 22 x 7. Philbrook Museum of Art, Tulsa, Oklahoma. Gift of Harrison Jedel. 1998.10.2*

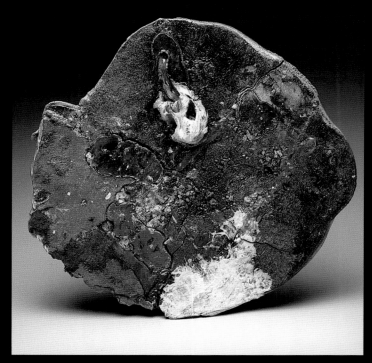

Plate 897, *1989. Raku-fired stoneware, 20 x 22 x 3.*

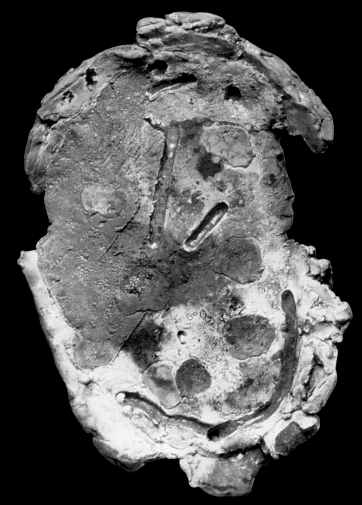

Plate 892, *1989. Raku-fired stoneware, 27 x 16 x 3. Arizona State University Art Museum, Tempe. 89.95.*

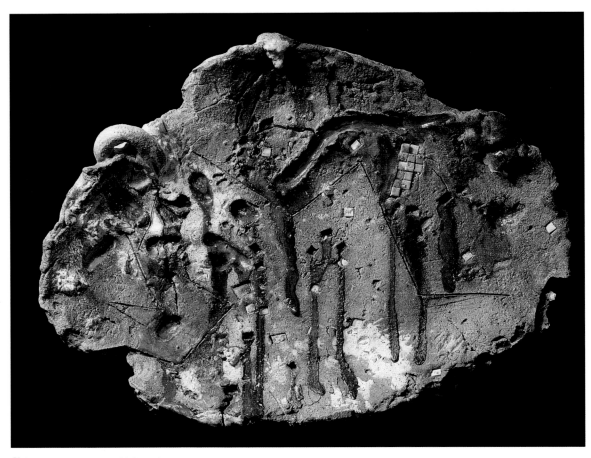

Plate, *1988. Stoneware with insertions, 17 x 17 x 2½.*

family members (for example, *Stephanie in the Stars*, 1975; see p. 92). In other respects, however, Leedy's imagery remained resolutely abstract as the artist continued to evolve a vocabulary of marks: the X, the dot, the slash, the line, the curve, and the circle.

Expressionist Plate (1986) is an echo of the expressionist plates of the mid-1950s, but with colored liquid-clay slips, or engobes, instead of polyester resins. Now fully in control of color, and needing no recourse to toxic industrial materials, Leedy once again treats the plate surface as a painter's canvas, often applying colors in numerous refirings, as if putting down paint in layers. Gradually, the clay body's retention of its rough appearance comes to be offset by effects of considerable richness and elegance of touch: Leedy searches the clay surface for cracks, rivulets, and imperfections, to which he adds glaze so that the fusion of surface and glaze seems perfect yet accidental. The irregularly edged stoneware slab plates of the 1980s and 1990s are among the artist's greatest achievements.

From these Leedy turned again, with renewed enthusiasm and mastery, to the stilted vessel. Using *anagama* techniques, he was able to attain an extraordinary range of surfaces, colors, and effects. *Black Vessel, White Stilted Vessel, Rounded Stacked Vessel* (see p. 145) and *Stilted Vessel with Tail* (all from 1993) reveal this wide range, from glistening metallic black to shimmering silvery white, burnished brown, and mottled reds and blues. Leedy's construction of sculptures in all media has always been an accretive, additive process, but in these works the balance of parts to whole is nearly perfect, with an appropriate combination of torn, cut, and extruded areas complementing the aspiring vertical forms. Their status as vessels is ensured by their central voids, but they are diametrically opposed to the petite decorative teapots that came to dominate American ceramics during the 1980s. As usual, Leedy was not just one step removed from the mainstream (which was marked at the time by a return to low-fired, decorated art pottery); he was

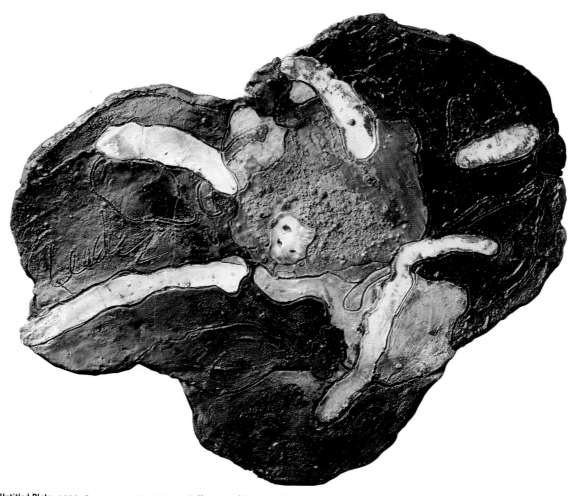

Untitled Plate, *1993. Stoneware, 21 x 29 x 3. Collection of Dr. Tony Racela.*

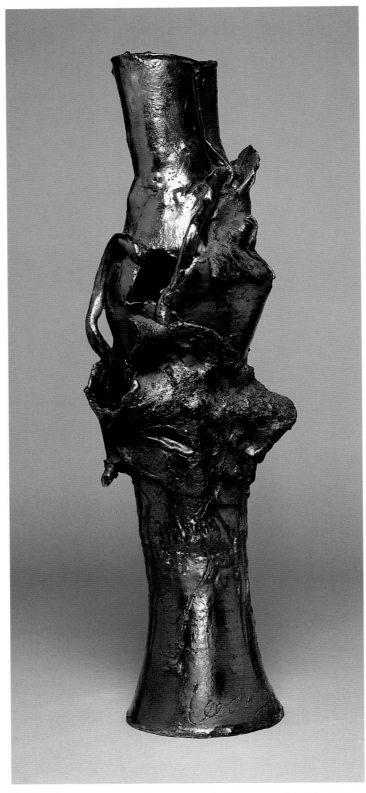

Black Vessel, *1993. Gas-fired and* anagama-*smoked stoneware, 42½ x 13 x 11½.*
Dale Chihuly collection, Seattle, Washington.

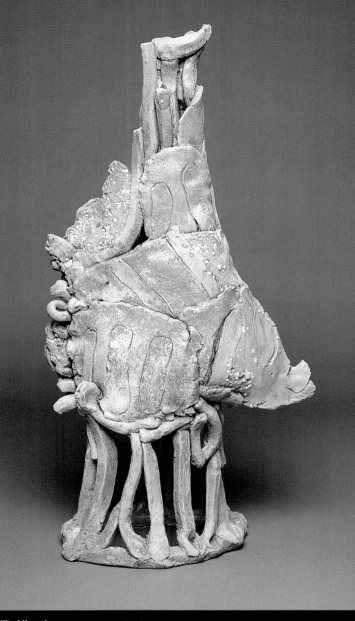

White Stilted Vessel, *1993. Anagama-fired stoneware, 36 x 19 x 10.*

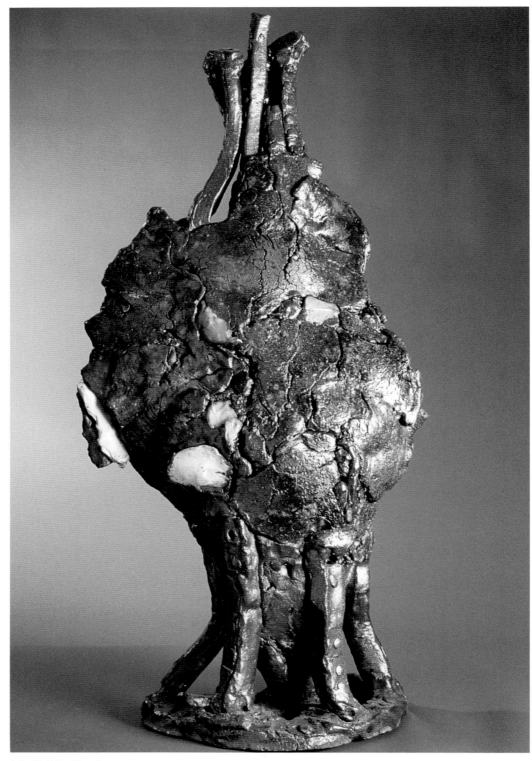

56

Lakeside Stilted Vessel, *1995. Ceramic stoneware with porcelain inserts, 46½ x 21 x 16. Daum Museum of Contemporary Art, Stauffacher Center for the Fine Arts, State Fair Community College, Sedalia, Missouri.*

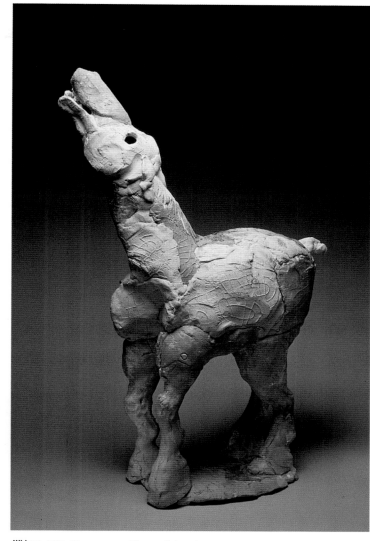

Whinny, *1981. Terra-cotta with porcelain, 43 x 24 x 10.*

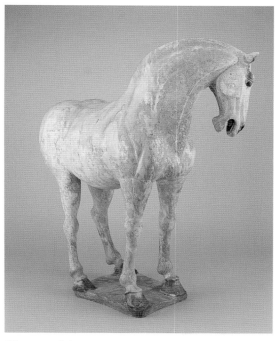

Chinese ceramic horse, *T'ang dynasty (618–907* C.E.*). Glazed pottery, 27 x 32 x 12. The Nelson-Atkins Museum of Art, Kansas City, Missouri. Purchase: The Hall Family Foundation Endowment for the Oriental Department.*

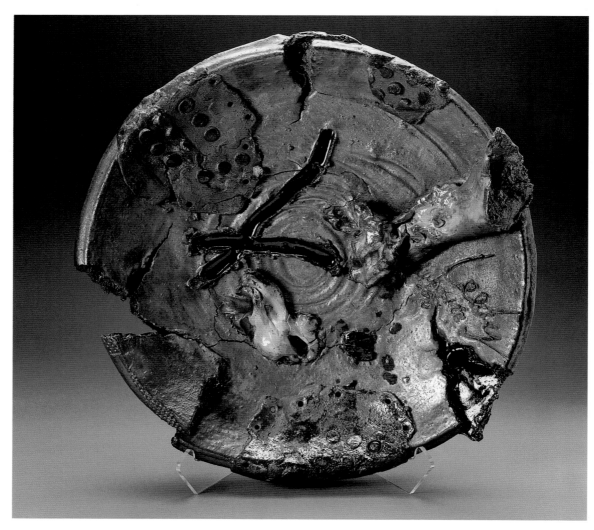

Lakeside Platter, *1995. Salt-fired stoneware, 26 diam. x 3 depth. Johnson County Community College, Overland Park, Kansas.*

also and simultaneously at least one step ahead.

The plates and platters of the late 1990s seem darker and more brooding in appearance, with lustrous blacks, deep blues, and only the occasional accent of a white porcelain insert. *From the Beginning (Plate with Whorl)* (1995) is among the strongest of these pieces. Almost slumped, defeated-looking, with its crushed and collapsed rim, *From the Beginning* may point to cosmological origins or to the artist's own beginnings near the cluttered clay pit in Richlands, Virginia. The central spiral is a near-cartoonish allusion to the thrower's wheel, given the way in which a plate will be altered by any conceivable amount of time on the wheel. Spots of blue echo the resinous colored dots on *Expressionist Plate* (1954) but are joined here by accents of gold and silver over black.

Before we move on to the tall figurative *Totem* series (see "The Figure Concealed, the Figure Revealed: Assemblages," pp. 73–97), several tall slab-built sculptures from 1980 merit comment. Of these, the most important is *Untitled*, nearly eight feet high, which emerges from the tradition of the Japanese rice-storage vessel. Upright and abstractly figurative, it is built in sections like the upper, middle, and lower thirds of the human body. Weaving, partly wobbling, it suggests a human figure bending or leaning, and with its tall wispy "hat" it exudes a quiet humor. After Leedy's explorations of American myth in his figurative sculptures of the 1960s and 1970s, *Untitled* rejects explicit social comment in favor of a meditation on effigy, the human surrogate, and the nature of adapting vessels to sculptural status.

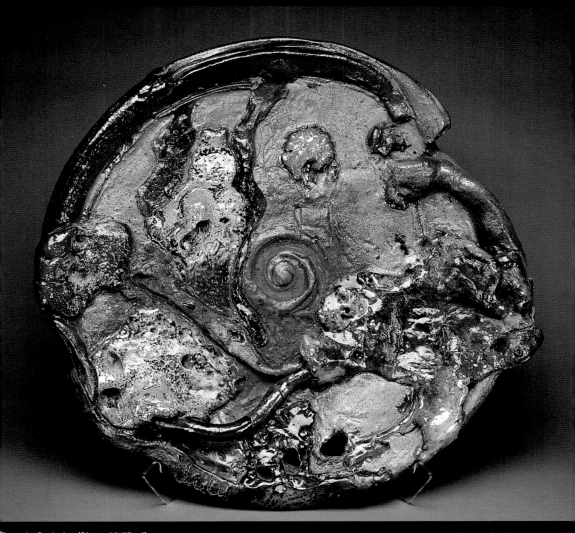

From the Beginning (Plate with Whorl), *1995. Salt-fired stoneware, 32 x 28 x 3. Los Angeles County Museum of Art, Gift of Harrison Jedel.*
AC1998.159.1

Untitled Stilted Vessel, *1953. Low-fired stoneware with resin glazes, 9 x 6.*

(left) Stilted Abstract Expressionist Plate, *1953. Pit-fired earthenware, 13 x 12 x 4.*

Untitled Bottle, *1960. Gas-fired stoneware, 13½ x 8¾ x 8½.*

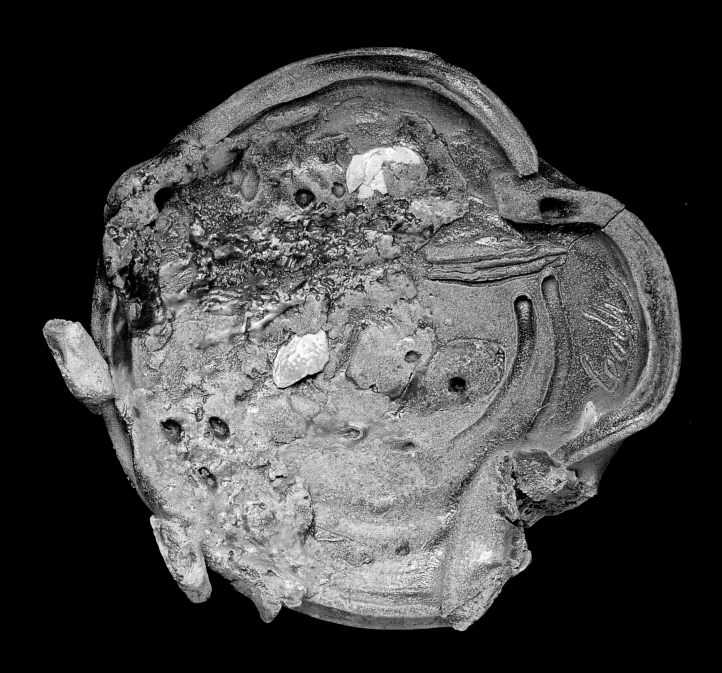

Untitled Plate, *1998. Anagama-fired stoneware with porcelain inserts, 22 diam. x 6⅔ depth.*

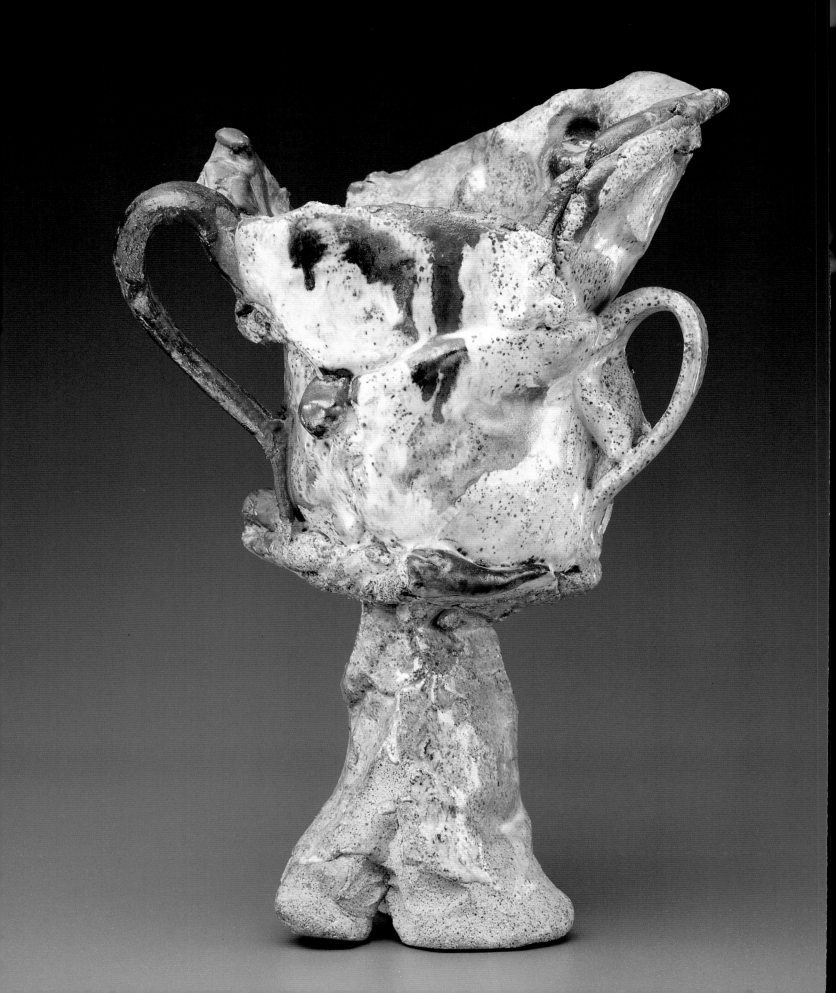

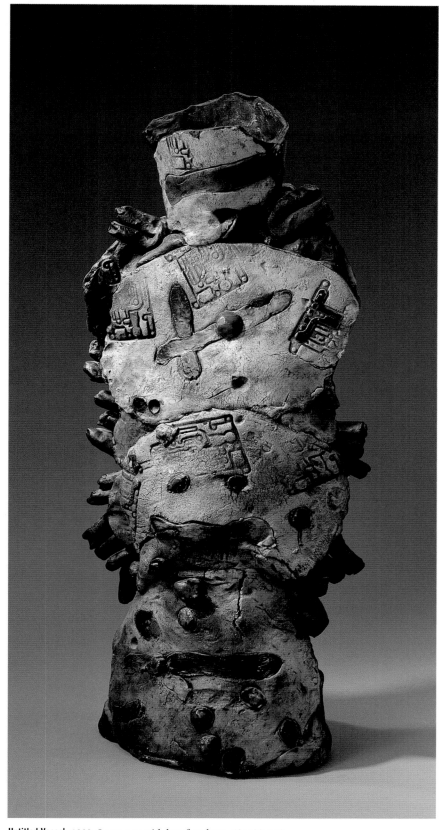

Untitled Vessel, *1982. Stoneware with low-fire glazes, 40 x 20 x 12.*

(left) Untitled Vessel, *1962. Gas-fired stoneware with glazes, 12½ x 8¼ x 6½.*

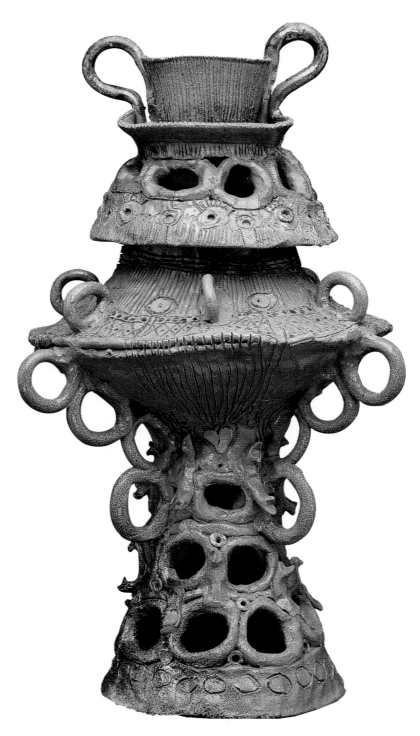

Celebration Cup, *1974. Salt-fired stoneware, 24 x 14 x 14.*

(right) Untitled, *1980. Stoneware with low-fire glazes, 94 x 32 x 14. Arizona State University Art Museum, Tempe. Gift of Maurice Grossman.*

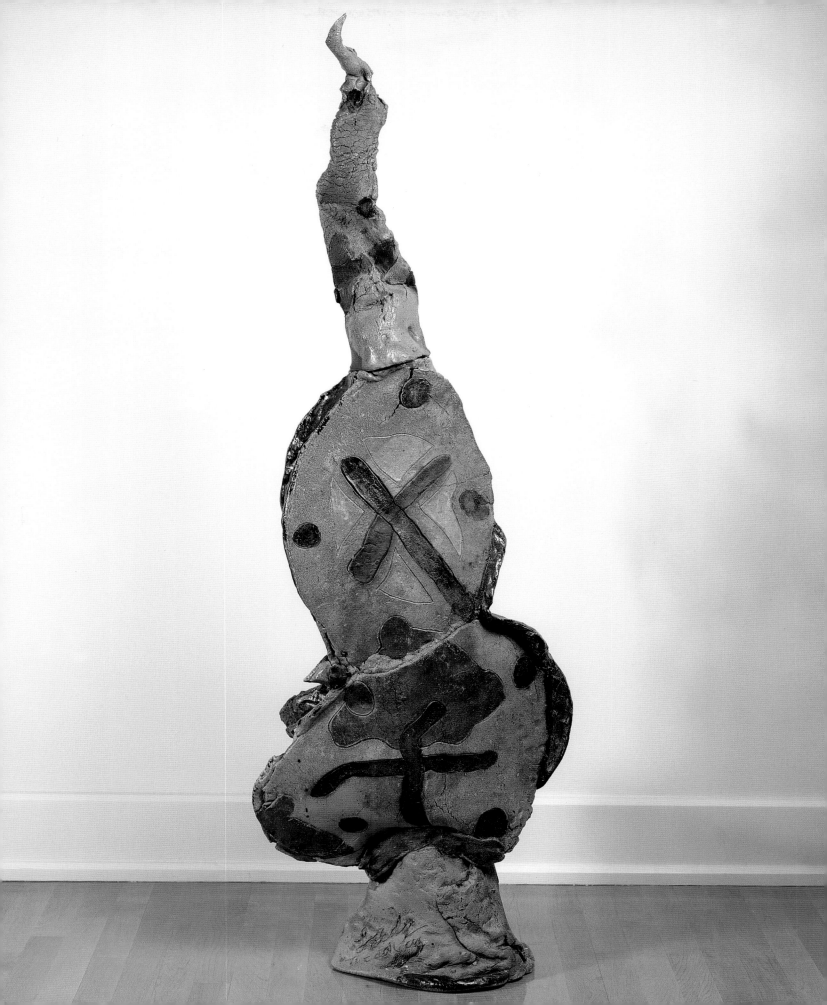

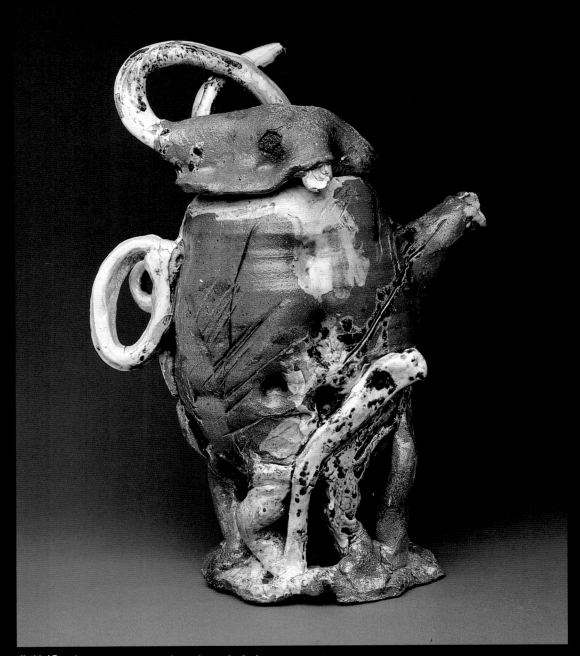

Untitled Teapot, *1965. Stoneware with engobes and salt glaze, 15 x 11 x 6.*

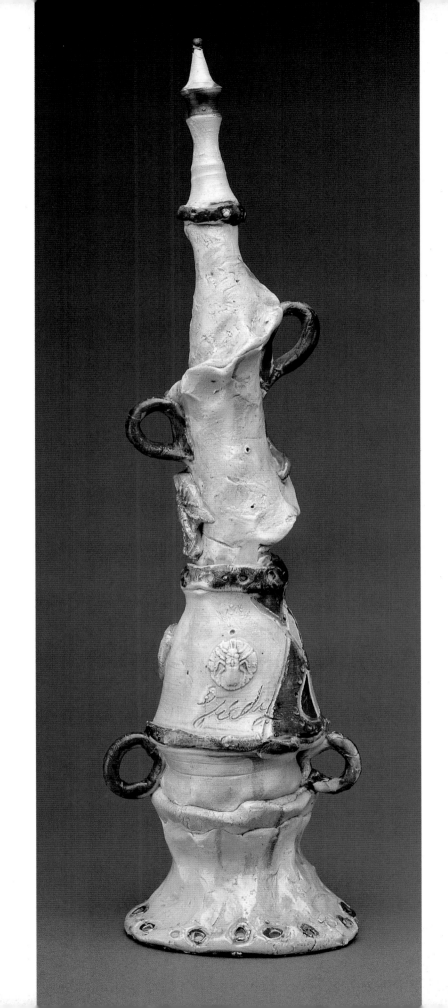

Untitled, *1967. Porcelain, 15 x 3¾ x 3¾.*

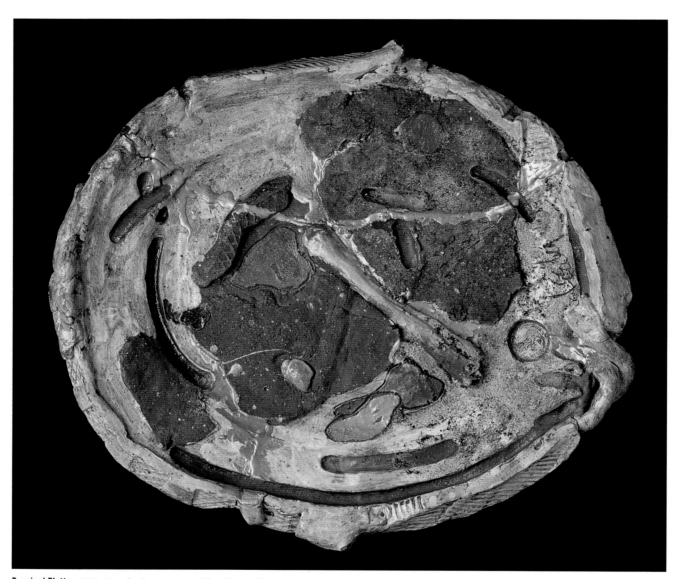

Repaired Platter, *1983. Gas-fired stoneware with gold mending, 22 x 26 x 4.*

(right) Plaque with Red Spots *(detail), 1985. Salt-fired stoneware, 20 x 26 x 3.*

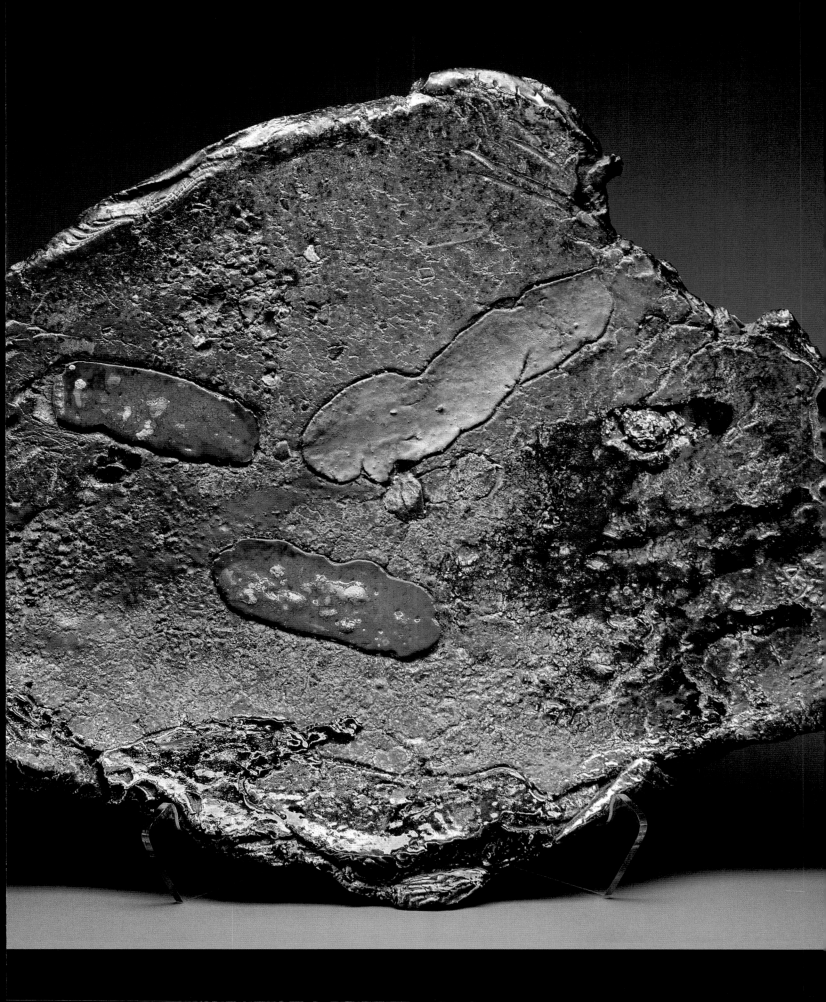

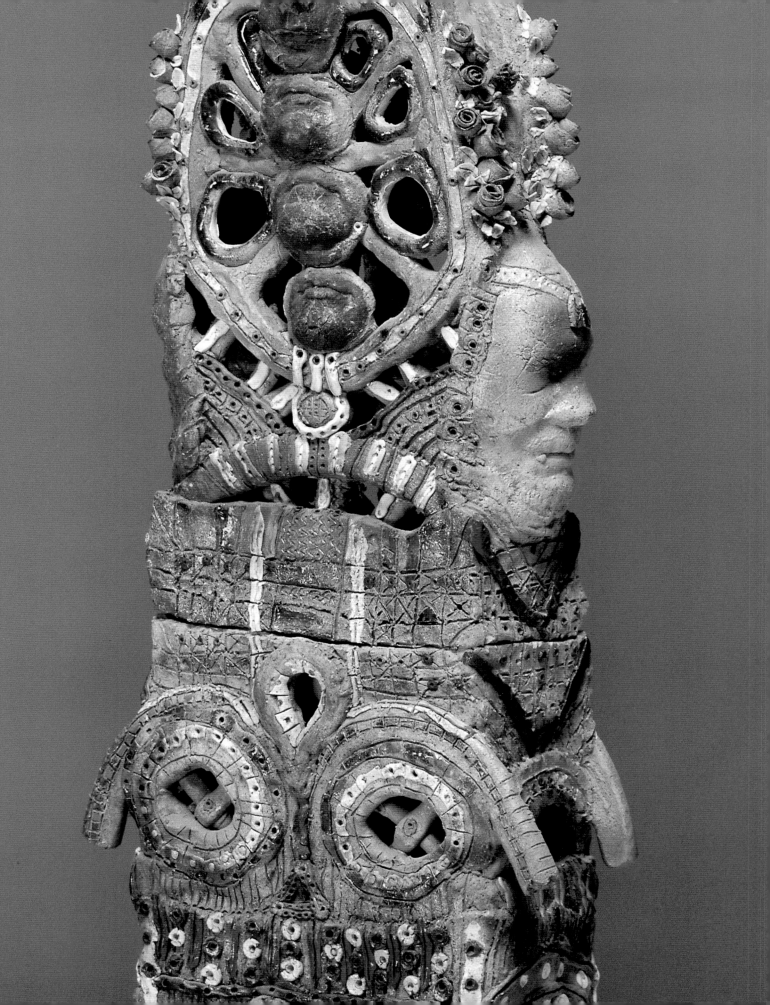

ASSEMBLAGES

From the earliest days of European porcelain, artisans had attempted to combine allegorical content with vertically commanding stature. For example, Conrad Link (1730–1793) fashioned a two-foot-high multiple-figure group, *Victory of Beauty over Envy* (1765), to help raise the clay from its earthbound fate and toward an elevated hierarchy of cupids and nymphs. Two hundred years later, Jim Leedy discovered that by creating stoneware sculptures in carved sections, fired separately and then reassembled atop one another, he could make clay sculptures of great height and visual impact; ceramic artists like Robert Arneson (1930–1992) and Michael Lucero (b. 1953) arrived at this discovery only years later. Thus Leedy's earliest stacked totems were at the time unprecedented in American ceramics for their height, as can now be seen, for example, in *Totem* (1973).

Leedy's figurative clay assemblages are an outgrowth of his stacked totems, with portraiture, commemoration, and homage as their originating motives. Although his tall abstract clay sculptures, taken as a whole, stress the assembly of parts, with no hierarchical discrimination, the figurative assemblages concentrate on the face. Throughout these works, the face appears, disappears, and reappears, all along the column or, usually, atop a complicated, accretive mass of clay loops, chains, filigrees, struts, and supports. This arrangement is in keeping with the precedent of Native American totems of the northwest coast, totems with which Leedy was fully familiar. In these totems the myth

opposite page:
Self-Portrait Totem
(detail),
1971.
Stoneware,
97 x 18 x 15.

can be read sequentially, from bottom to top, or perceived instantaneously through the simultaneous presence of all the narrative elements.

An early painting of Leedy's, *Fear* (1965), shows the white-outlined figure of a woman's body concealed within a black man's face. More specifically political than his later artworks, *Fear* was created in the racially segregated environment of Athens, Ohio, and is clearly about the plight of African Americans during the civil rights struggle of the 1960s. Not only did this painting set out the motif of the figure's concealment, it also set the stage for the artist's explorations of the figure, at a time when modernist abstraction was dominating the nation's art. Ever

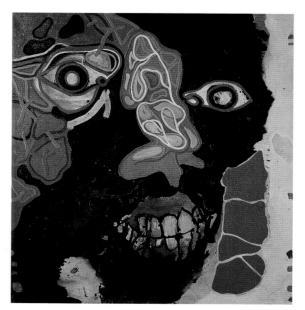

Fear, *1965. Oil on canvas, 63 x 59½.*

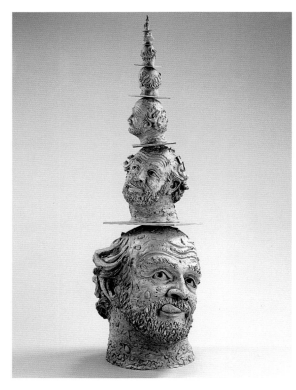

Robert Arneson, *(1930–1992),* **Poised to Infinity,** *1991. Bronze, 86 x 30 x 28½. © The Estate of Robert Arneson. Licensed VAGA/New York.*

true to his own vision, and totally comfortable combining figuration and abstraction in the same work, Leedy demonstrates yet again in *Fear* how easily his artistic imagination can move across material boundaries, from painting to sculpture to assemblage, with idea always as the unifying force. His ceramic assemblages were to take him to a new artistic maturity and level of accomplishment.

Over the ensuing two decades (1975–1995), Leedy's figurative clay assemblages developed into a periodic exploration of the American male and his roles: father, son, lover, politician, leader, friend, and artist. Nearly all Leedy's subjects were friends, or patrons known to him, and so he used ceramics as a genre utterly appropriate to and worthy of his commemorating the people close to him.

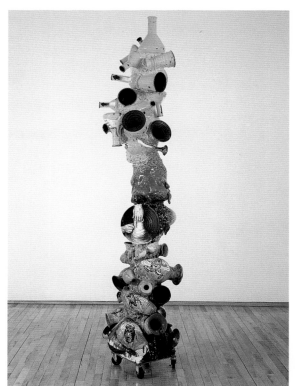

Michael Lucero *(b. 1953),* **Sunburn,** *1998–1999. White earthenware with glazes and metal, 106 x 27 x 24. Courtesy of R. Duane Reed Gallery, Chicago.*

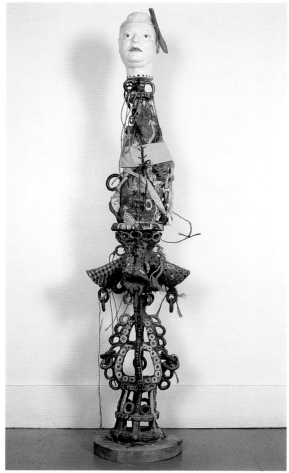

Untitled, *1969. Ceramic and glazes, 41½ x 26 x 9½. Collection of the Nova Scotia College of Art and Design, Anna Leonowens Gallery, Halifax, Nova Scotia.*

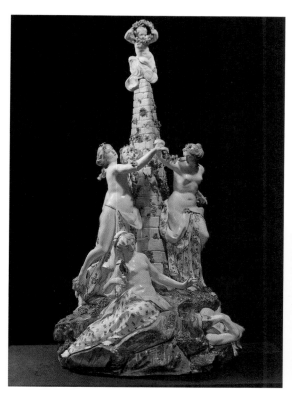

Conrad Link *(1730–1793),* **Victory of Beauty over Envy,** *1765. Frankenthal porcelain, 24 h. The Nelson-Atkins Museum of Art, Kansas City, Missouri. Purchase: Nelson Trust.*

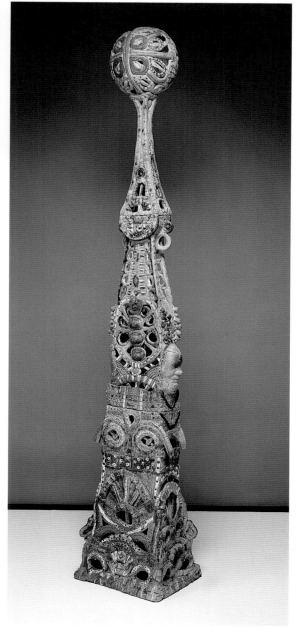

Self-Portrait Totem, *1971. Stoneware, 97 x 18 x 15.*

Jim and Keith Leedy at Berkeley Pit, Butte, Montana.

All American Boy Trophy (1968) starts close to home: the artist's son, Keith, born in 1952. Deconstructing the traditional notion of the presentation trophy—shiny, diminutive, segmented, and orderly—the thirty-eight-year-old father set a pure white stoneware form of his son's head atop a roughly fashioned clay sphere, which in turn surmounts two opposing masks that represent Leedy ancestors. The heads, appropriately anchored in brown clay, face out, eyeless, toward the viewer. Only at the sculpture's base, with its trophylike inscription ALL AMERICAN BOY, does the sociocritical dimension emerge: in 1968, with the United States at the height of its military involvement in Vietnam, Leedy is commenting on the fate of young American men chained to such Establishment traditions as military service, and he is rendering precious the children of America about to die in southeast Asia. This fear for the boy's future safety is reinforced by the three darkened feet at the base, beneath the white trophy form. The chain was to become a frequent formal motif in Leedy's work, but in *All American Boy Trophy* it takes on real symbolic weight, linking both the trophy section and the three feet to the sphere, which itself is clearly an analogue of the world. From this perspective, such obligations as "supporting" America's global involvement through military service are seen as inescapable and inevitable.

Two prominent Missouri residents whom Leedy admired immensely, Harry S. Truman (1884–1972) and Thomas Hart Benton (1889–1975), would be the next subjects of his monumental portraiture, and among the other people so honored by Leedy were two more who were very important personally to the artist: Harrison Jedel, Leedy's first major patron, and Jim Morgan (1937–1982), a widely beloved Kansas City art dealer who was killed in a motorcycle accident while en route to St. Louis. (Leedy, invited to accompany Morgan on that occasion, had declined.)

Truman, thirty-third president of the United States, might seem another likely subject for Leedy's ongoing critique of the American male, but *The Buck Stops Here* (1962–1964) is less critical of Establishment institutions than is *All American Boy Trophy*. In fact, *The Buck Stops Here* is Leedy's major statement on American politics; Leedy, like Truman, can be characterized as a pragmatic liberal. This sculpture, more than seven feet high, with imagery piled on, not only refers to the bespectacled former president's persona (at the time, he was living ten miles away from Leedy, in Independence, Missouri) but also includes symbols of the presidency (two American eagles) and of Truman's role as peacemaker after World War II (four "doves of peace"),

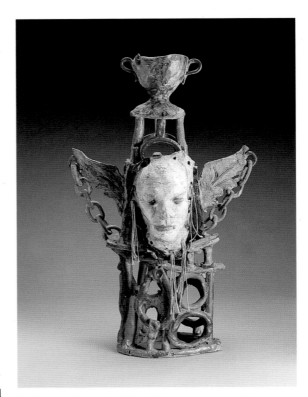

Trophy, *1965 (front view). Handbuilt stoneware, applied glazes and stains, with commercial string, 27⅛ x 17¼ x 9⅞. John Michael Kohler Arts Center, Sheboygan, Wisconsin.*

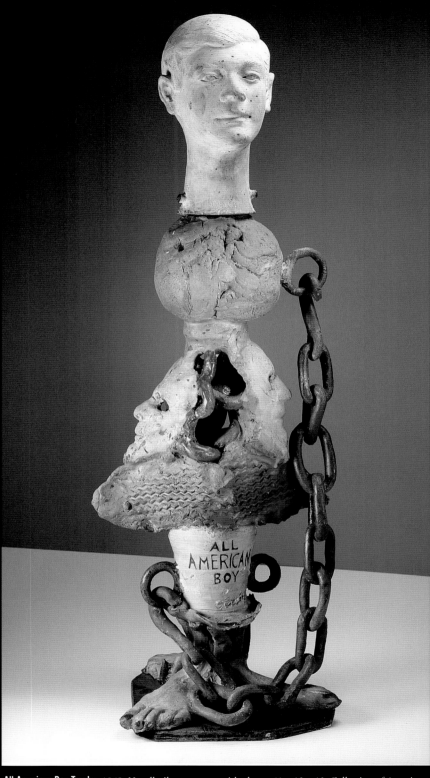

All American Boy Trophy, *1968. Handbuilt stoneware with glazes, 41 x 12 x 13. Collection of American Craft Museum. Gift of the Johnson Wax Company from Objects U.S.A., 1977. Donated to the American Craft Museum by the American Craft Council, 1990.*

ALL
AMERICAN
BOY

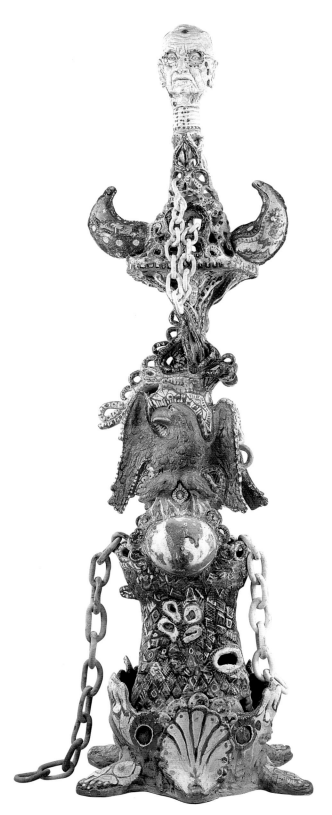

The Buck Stops Here, *1962–1964. Four-part glazed stoneware, 88 x 22 x 18. The Nelson-Atkins Museum of Art, Kansas City, Missouri. Gift of Mr. and Mrs. Jerome Nerman.*

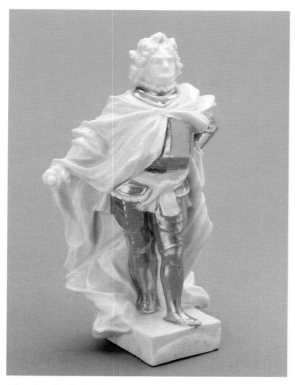

Johann Joachim Kretzschmar *(1677–1740)*, **Augustus the Strong, Elector of Saxony and King of Poland,** *1715–1720. Hard-paste porcelain, gilded, 4⅜ h. Manufactured by Meissen. The Nelson-Atkins Museum of Art, Kansas City, Missouri. Purchase.*

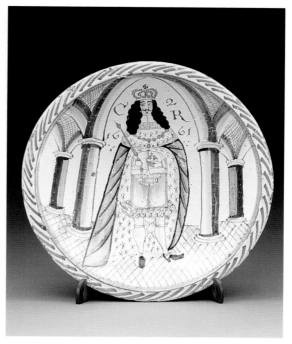

Coronation dish, *1661. English ceramic. Lambeth Delft pottery, 12½ diam. The Nelson-Atkins Museum of Art, Kansas City, Missouri. Gift of Mr. and Mrs. F. P. Burnap.*

along with a globe alluding to Truman's role as cofounder of the United Nations, as well as the ubiquitous chains. The two protective horns below the head of Truman may allude to Missouri beef country, but they are also ancient Minoan symbols of power. Meticulously glazed in great detail, *The Buck Stops Here* sticks to red, white, and blue, for obvious reasons. The oyster shell at the sculpture's base contains a sprouting bulb, and perhaps shell and bulb together are a double symbol of growth and hope. The oyster shell is also a medieval symbol of religious pilgrims. Leedy honors Truman by literally elevating him above it all but also by elaborately decorating the entire sculpture with dazzling linear filigree: bronze is not the only material suitable for national monuments or presidential statues.

Leedy met Benton in 1965, when the feisty dean of American regional art was seventy-six years old. Although Leedy created several works of art using Benton's likeness, *Thomas H. Benton Bank* (1972) developed from a suggestion by the older artist. This bank, perhaps the closest Leedy got to

Pop Art, has an effigy of Abraham Lincoln beneath a head of Benton, as an allusion to the thousands of souvenir banks using the thrifty sixteenth president's image. (A companion piece, *Cindy as Mary Todd,* 1972, plays off the Lincoln bank even more explicitly, with silvered wax castings of Lincoln that adorn a base below the head of a woman resembling Lincoln's tormented wife, Mary Todd.) *Benton Memorial Portrait* (1976) concludes Leedy's explorations of the contradictory currents of fame, neglect, reputation, and derision that accompanied Benton's career. A bronze head is appended to a series of

Thomas Hart Benton, Kansas City, Mo., ca.1965.

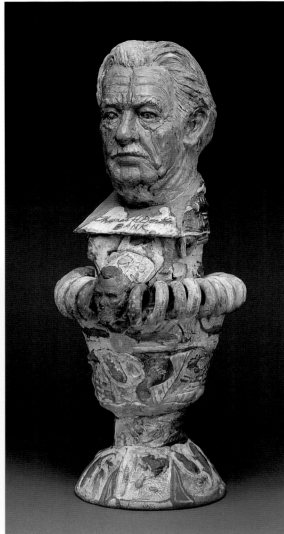

Thomas H. Benton Bank, *1972. Painted earthenware, 25 x 12 x 12.*

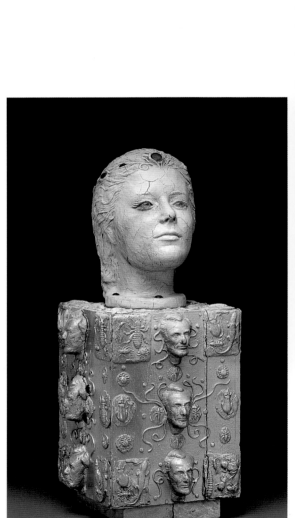

Cindy as Mary Todd, *1972. Unfired clay and wax, paint,*
26 x 12 x 12.

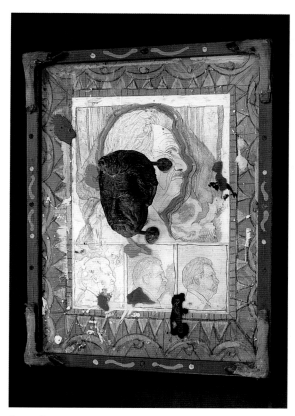

Benton Memorial Portrait, *1976. Mixed media, bronze,*
34½ x 27 x 9.

profile images under glass. The spatters of paint
aimed at Benton are references to his most famous
student, Jackson Pollock, whom Benton met while
teaching at the Art Students League in New York.
With the darkly burnished bronze head, Leedy is
also commenting on the older Missouri-born artist's
crusty Establishment status in the 1930s and 1940s.
The image of Benton, bluntly emerging from the flat
drawings, confronts the viewer as unapologetically
as Benton himself would have done in real life.

The four sculptures commissioned by Jedel
are somber effigies of the patron and his father,
Sylvan "Jed" Jedel (1896–1991), a prominent busi-
nessman. These sculptures, pivotal in Leedy's
move from clay to found-object assemblages, are
extremely important transitional works. The
darkest of the group, *Jed Jedel with Chain* (1971),
sets the patriarch above a cluster of hands out-
stretched as if reaching for money, and with the
stern visage cast in bronze—this is Leedy's second
sculpture to combine bronze and clay—another
material element of permanence is added. Beneath

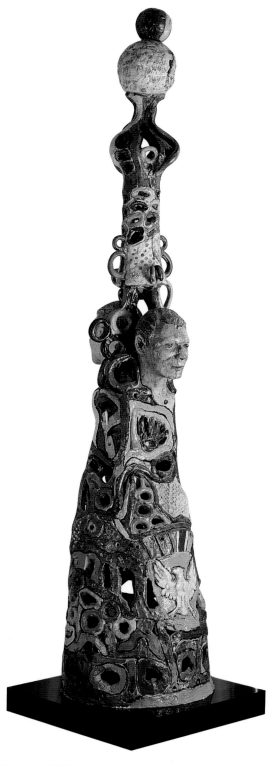

Harrison Jedel Totem, *1969. Stoneware with glazes, 84 x 31 x 30.*
Harrison Jedel collection, Kansas City, Missouri.

81

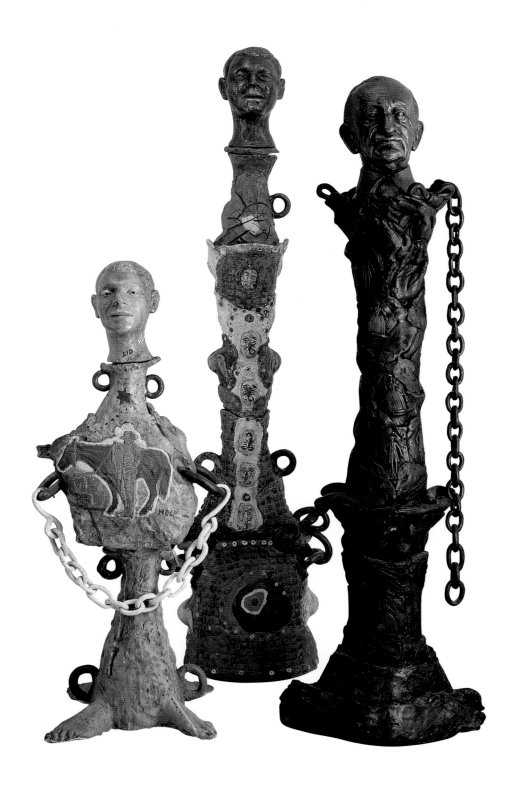

(left to right) Harrison Jedel, *1969, stoneware, 37 x 26 x 14;* **Harrison Jedel Totem,** *1970, stoneware and bronze, 72 x 30 x 24;* **Jed Jedel with Chain,** *1971, stoneware with bronze head, 66 x 26 x 12. All three works from Harrison Jedel collection, Kansas City, Missouri.*

Assemblages

the head, casts of a Colonial-era man and woman are randomly placed on a long black column. This column and the head rest on a four-part plinth. The suspended chain, significantly unlinked to any other object, is perhaps a symbol of Jedel's freedom as a businessman in the open economy of the United States.

The three Harrison Jedel portrait-totems have even more highly developed iconographies. For example, *Harrison Jedel Totem* (1970) includes seven stacked scorpion medallions on the brown clay column beneath a bronze head of Jedel (both Leedy and Jedel were born in the astrological sign of Scorpio), and a faceted patterned base may allude to a cauldron in a steel factory. A shorter, informal piece, *Harrison Jedel* (1969), uses Jedel's head as a vessel lid above a hollow form decorated with a horse and rider. Here, Leedy is connecting Jedel and his family to western American history (they settled in Kansas City in 1890). *Harrison Jedel Totem* (1969), the most ambitious and colorful of the grouping, features a head of Jedel midway up the totem pole, so that the patron's image, rather than crowning the overall sculpture, is incorporated into it. This piece, seven feet high, uses such motifs as the American eagle first seen in *The Buck Stops Here*. It celebrates color and form, pushing the limits of conventional portraiture and making an oblique point about Jedel as a modernist art collector: he is literally surrounded by abstract elements chronicling Leedy's vocabulary of shapes; the loops, curves, and spheres accumulate into a single freestanding sculpture. In the four pieces commissioned by Harrison Jedel, Leedy does not so much conceal the figure as incorporate it into the autonomous artwork, thus reinventing commemorative sculpture.

Leedy's culminating masterpiece among the clay assemblages is also a tribute to Jim Morgan. At the time of his tragic death, Morgan was one of the most important art dealers in the Midwest. When Morgan died, a number of prominent artists—a group that included Leedy, William T. Wiley, John Mason, Patti Warashina, Peter Voulkos, and Rudy Autio—each made a work for a memorial exhibition that was held the following year in Kansas City

at the Crosby Kemper Gallery and curated by Morgan's widow, Myra. Ironically, what turned out to be Leedy's memorial piece—*I Totem So* (1982)—had been commissioned by Morgan before his death: two weeks before the accident, he had insisted that Leedy come to his home and make life masks of him and Myra. When Leedy was invited to participate in the tribute show, he decided to make this previously commissioned piece all white, to symbolize innocence and mourning, as in Chinese culture. The title of the work, unusually simplified and reductive for Leedy, is of course a pun and recalls the artist's warnings to Morgan about the dealer's legendary motorcycle jaunts. In the uppermost

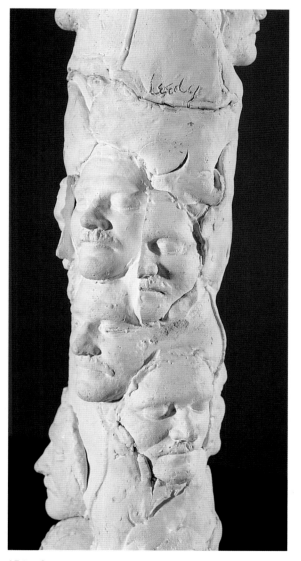

I Totem So *(detail), 1982. Three-piece ceramic, 236.5cm x 50.8cm. Spencer Museum of Art, University of Kansas, Lawrence.*

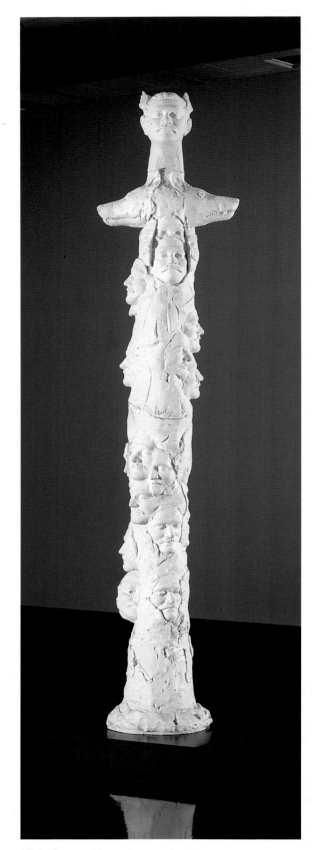

I Totem So, *1982. Three-piece ceramic, 236.5cm. x 50.8cm. Spencer Museum of Art, University of Kansas, Lawrence.*

portion of the figure's head, the hair has wings, as if Morgan were an angel about to take flight. It is also symbolic of how much Morgan, an ex–airline pilot, loved speed. On each of the faces the eyes are closed, asleep in death. With the clay unpainted and unglazed, there is also the sense of an unfinished work of art—and an unfinished life.

Leedy's mixed-media and found-object assemblages flowered in the 1975–1985 period but are in some ways extensions of his abstract expressionist paintings. As already mentioned (see "Paintings," pp. 9–37), the 1958 work *Life Source*, the 1959–1969 work *Floating Fragments*, and the 1969 work *Behind the Sun* include appended clay bits. Moreover, an even earlier work, *Holy Figure* (1952), anticipates Leedy's crossing the boundary, in the later assemblages, between painting and sculpture. With frame fragments missing, and with applied buttons surrounding an enhaloed male figure, this work suggests references to outsider art, Plains Indian art, and perhaps Coptic Christian art.

 Dream World (1971), a companion piece to *Holy Figure* made nearly twenty years later, repeats the decorated, recycled frame and the inner single figure but adds the background of a dreamlike landscape. Upon closer inspection, figures of eight other heads and facial fragments appear, Abraham Lincoln's among them. The central figure is ambiguously gendered, with cascading shoulder-length hair. Strands of colored clay are applied as radiating streams of light and energy. A multi-colored grid contains further images of rats, frogs, and insects. The face fragments—chins and mouths—underscore how Leedy both conceals and reveals the figure, approximating the synecdoche, both foreboding and enchanting, of dream imagery. There is a hallucinatory quality that perfectly matches the tenor of the early-1970s zeitgeist.

 Leedy's assemblages seem paradoxical: hyper-realistic and crammed with detail, but also fantastically escapist and unrealistic. Over and over, the artist's symbolic use of three-dimensional representation leads the viewer into the piece, only to disrupt expectations and unleash imaginative alternatives to

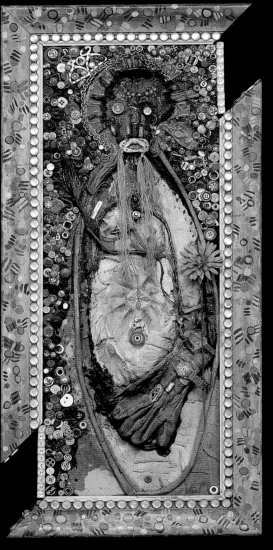

Holy Figure, *1952. Mixed media, 41½ x 19½ x 3¼.*

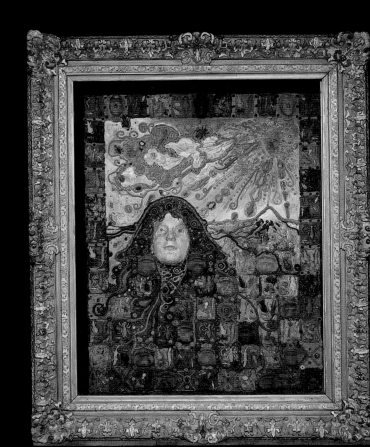

conventional representation: the viewer, attempting to unravel patterns of learned iconography, is plunged into the subjective irrationality of the artist's mind.

Three works appear, in retrospect, to be a triptych of statements about life, death, and the afterlife. They form the crux of Leedy's most important found-object assemblages, and they constitute his highest achievements in the genre. *The History of Christianity* (1981), *Remains* (1980), and *Life After Life* (1975) can be seen as the artist's expressions of doubt and hope with respect to mortality.

Severe and frontal, *The History of Christianity* sets a plaster madonna relief over a blackened background, with applied thorny rosebush branches. Playing off earlier uses of framing devices (in *Holy Figure* and *Dream World*), whitened bone fragments surround the entire work. A human skull (possibly Adam's, as in medieval and Renaissance paintings where the skull at the foot of the cross represents the Fall) is in the lower left-hand corner, next to a tableau of cattle bones supporting the Virgin Mary. Here, Leedy is also picking up the thread of some of his earliest paintings and prints. Like the 1958 work *Symbols of Worship* and *The Annunciation*, from 1961, *The History of Christianity* rebels against conventional religious pieties, associating Christianity instead with carnage, death, and darkness.

The even gloomier *Remains* is perhaps Leedy's darkest statement as an artist to date. Here no hope of eternal life is permitted; the assemblage proposes a charred, decayed purgatory where more fragments of animal carcasses are tossed in with weird plastic toys. A stuffed lizard or iguana climbs up the side of the painting, perhaps the sole survivor of the fires of a world cataclysm. *Remains*, executed near the end of the Cold War, is a grim reminder of the threat of nuclear holocaust.

Life After Life may propose a suspended state of existence, not quite hell or purgatory but definitely not a reunion with the Divine Being. The picture, hierarchical in structure, features a boneyard at the base, beneath an ominous square of rubble embedded with shells and more bones and centered by a mysterious animal skull with a protruding red

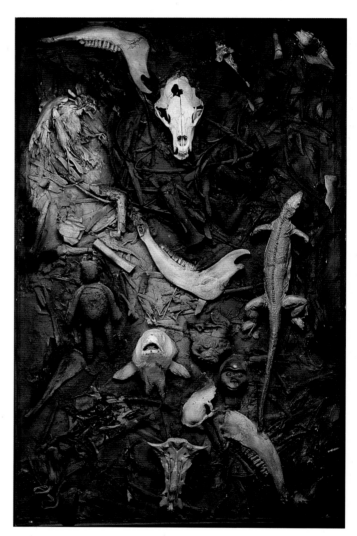

Remains, *1980. Mixed media, 66 x 41 x 10.*

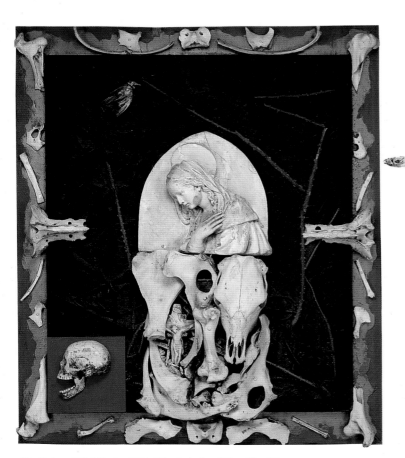

The History of Christianity, *1981. Mixed media, 67¾ x 57 x 8½.*

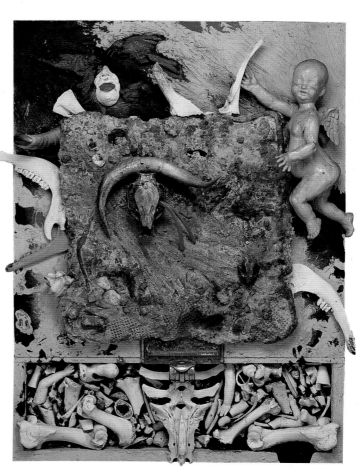

Life After Life, *1975*
Mixed media with bones, plastic, paint, 61¼ x 44 x 15.

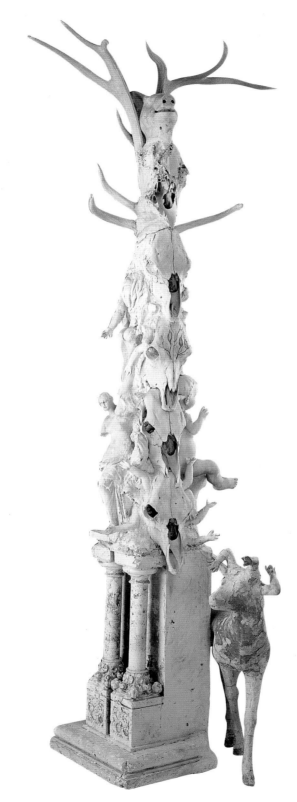

History Totem, *1975–1980. Mixed media, 123 x 48 x 31½.*

forked tongue. The latter image, comparable to medieval descriptions and depictions of the devil, seems to suggest that the afterlife may be a further extension of the pain, torture, and suffering so endemic to the twentieth century.

One advantage of the wall-mounted assemblages is their allowing Leedy to combine, within a confined area, a range of objects that stand in as allegorical symbols: no matter how explicit or realistic the nature of such objects, their juxtaposition forces the viewer to construct or unravel a narrative of implication and imaginative suggestion. But two freestanding works also merit comment and analysis here: *History Totem* (1975–1980) and *Self-Portrait as Wizard* (1965). Both are ambitious and telling.

In *History Totem*, Leedy once again uses white to imply death. As we have seen, Leedy has never shied away from tackling grand, not to say grandiose, subjects: religion, life, death, America, the role of politicians, the earth, ecology. Could *History Totem* be nothing less than a memorial to Western civilization? With its double-columned base, this work suggests roots of contemporary society and culture in classical Greece. Small human effigies, in the form of baby dolls, and a replica of *Venus de Milo* (ca. 100 B.C.E.) are embedded in the rising column.

Despite Leedy's claims of nonhierarchical composition, *History Totem* can be read from bottom to top, and when it is read in this way it posits a hopefulness (the babies; such an apogee of art as represented by the Greek fragment from the island of Melos). These elements are mitigated, however, by the recurring appearance of animal skulls and bones and by the outstretched arms in the sculpture's upper area. The dominant presence of the crowning antlers—which act as linear elements, extending the work upward and outward into space—together with the lawn ornament of a fawn at the base, may suggest the likelihood that nature or the animal world will outlast humanity. The plas-

ter fawn, like the stuffed goat in *Monogram* (1959), by Robert Rauschenberg (b. 1925), has a mute, startled presence; it does not so much complete the composition as wander past it in a daze. Like *Remains*, the entire composition could be another vision of nuclear aftermath; everything is dusted with a charred and whitened ashlike covering.

To move from the dangerously universal to the perilously personal, *Self-Portrait as Wizard* presents an image of the artist as a fragile captive of his own body—and of his studio activities. Anticipating the outstretched hands that support a head in the 1971 work *Jed Jedel with Chain*, this self-portrait depicts the artist as a disembodied yet strangely animated entity. Bound with rope, commercial string, and painted wire, the effigy self-portrait offers a view of the artist himself as an assemblage of disparate parts: clay, thread, plaster, paint, and two plastic strawberries. Topped with a wig and a hippie headband, the artist seems both a prisoner of his own talent, of the compulsive need to create in an additive manner, and bound literally (rope, string, wire) and metaphorically by such aesthetic procedures. The extreme individuality required to create art of lasting value is satirized here with great poetic sensitivity and gentle humor.

An even greater danger for the artist than solitude is the suspension of the controlling artistic ego; the act of facing this danger would preoccupy Leedy sporadically over a ten-year period and eventually lead him from the intensely inward ruminations of his clay and found-object assemblages to public collaborations, where even the sky ceased to be a limit. Jim Leedy, who has willingly endured the solitude of the studio and embraced the arena of activity, with its own liberations and constraints, would next break out and find balance in collaborative, highly successful efforts to create art in public places.

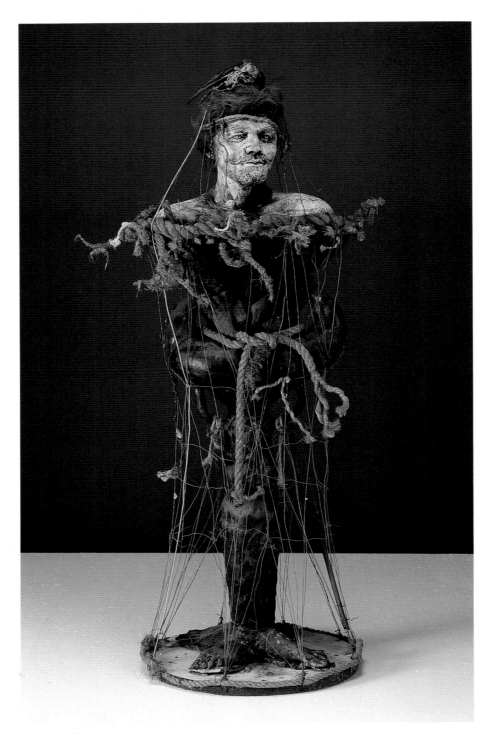

Self-Portrait as Wizard, *1965. Mixed media, 53¼ x 22½ x 18½.*

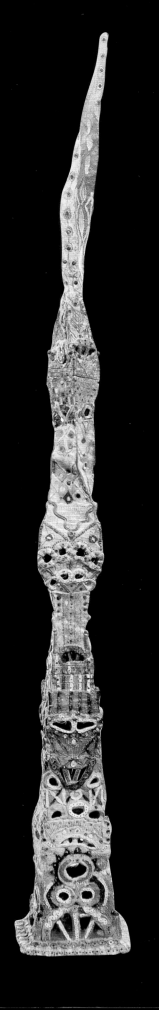

Totem, *1973. Stoneware with slips, stains, and salt glazes, 104 x 12 x 12. Western Illinois University Art Gallery, Macomb.*

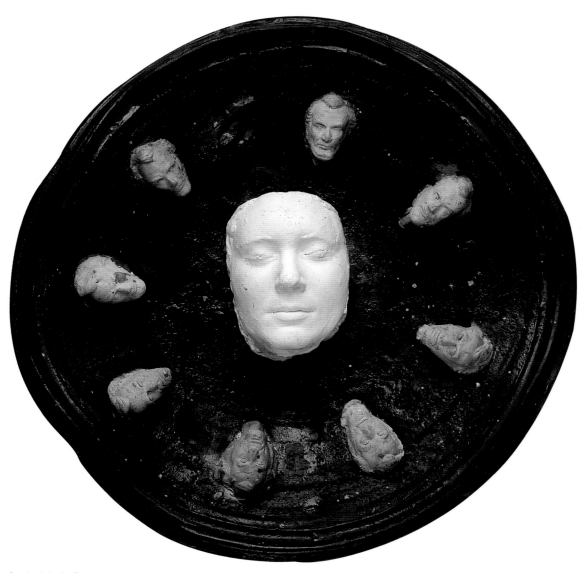

Stephanie in the Stars, *1975. Stoneware, 23 x 23 x 5.*

(right) Trophy *(reverse view), 1965. Handbuilt stoneware, applied glazes and stains, with commercial string, 27⅛ x 17¼ x 9⅞. John Michael Kohler Arts Center, Sheboygan, Wisconsin.*

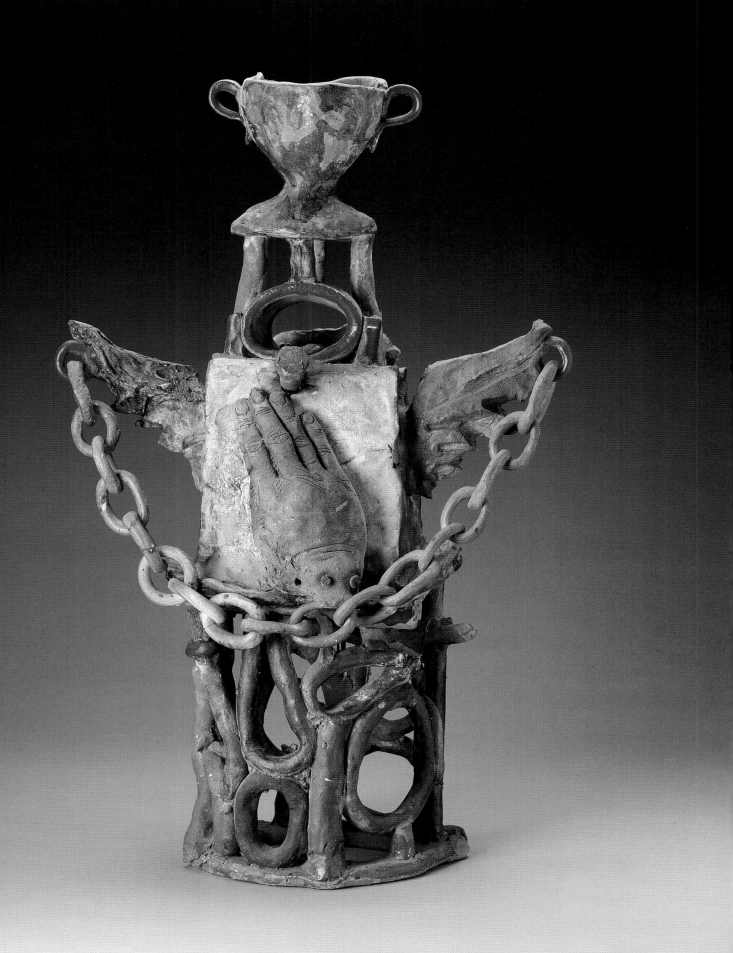

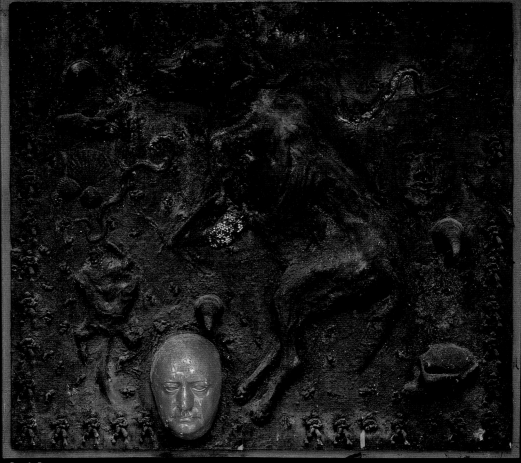

Pope's Dream, *1968. Mixed-media assemblage, 46¼ x 50 x 12.*

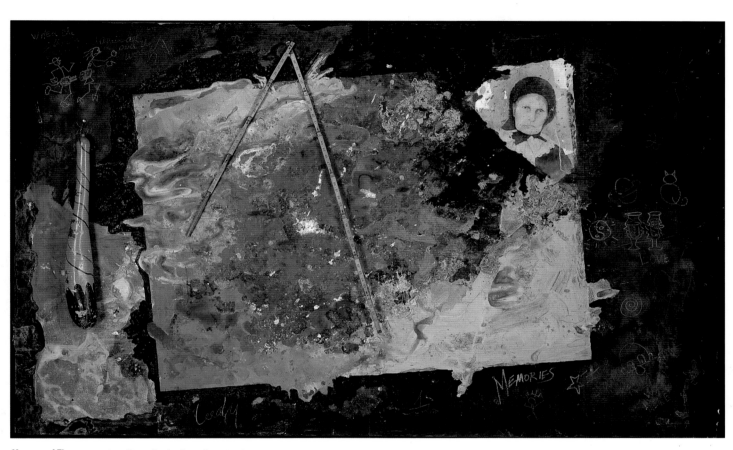

Measure of Time, *1990. Acrylic and mixed media, 58 x 96.*

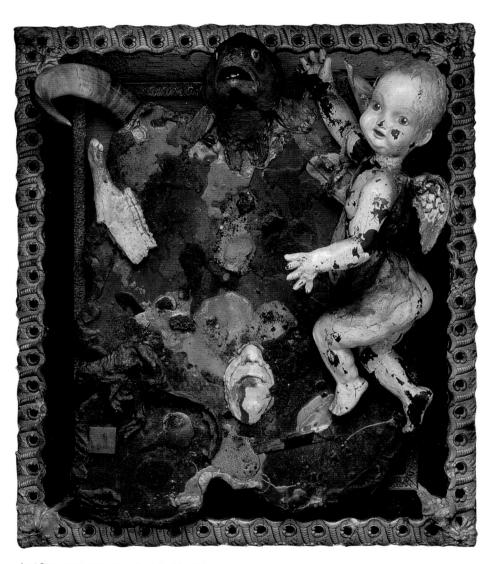

Last Born, *1983. Mixed media, 36 x 31 x 12.*

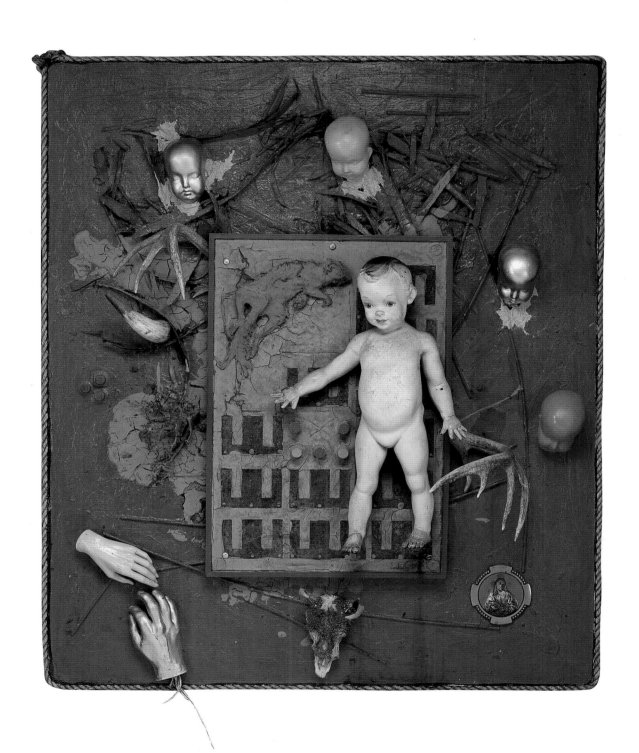

The Beginning, *1981. Mixed media, 58 x 49 x 12.*

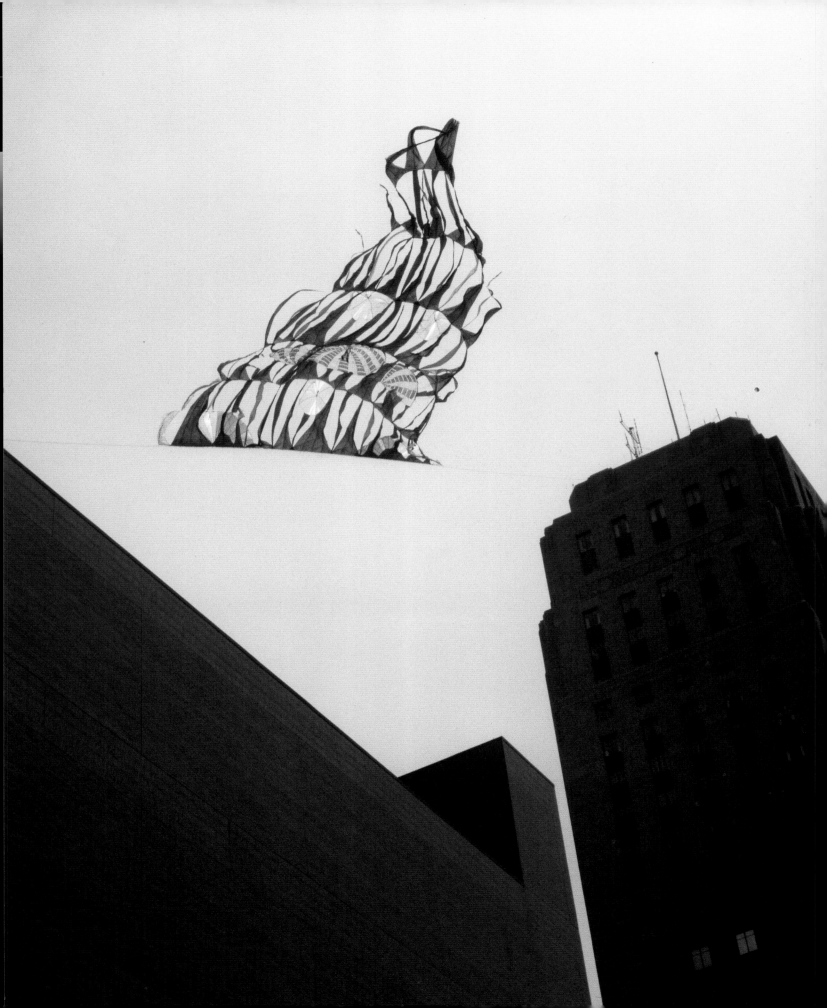

COLLABORATIONS

Although Jim Leedy continued to paint, sculpt, and throw pots and plates during the 1975–1995 period, his collaborations during this time with other artists (and with art students) on large-scale public projects constitute an important part of his overall artistic achievement. His radical dissolution of artistic ego in favor of collaborative artistic decision making has touched a wide variety of media and genres.

The collaborations began in Kansas City, Missouri, in 1971, with one elevated nylon sculpture, the first in the *Sky Art* series. This series—ten outdoor elevations between 1971 and 1985 that involved the display of twenty works—continued in Chicago; Pittsburgh; Flagstaff, Arizona; Billings, Montana; and Lubbock, Texas.

Between 1980 and 1983, Leedy also participated in a series of collaborative ceramics workshops with Peter Voulkos and Rudy Autio, which culminated in 1985 in a comprehensive exhibition at Northern Arizona University Art Museum and Gallery. Subsequent workshops with Voulkos, Autio, Donald Reitz (b. 1929), and Donald Bendel (b. 1935) took place not only in the United States but also in New Zealand and Norway. Collaborative ceramic murals in Canada and Japan and in the United States grew out of these demonstration workshops but entailed greater public involvement, going so far as to use face casts of local community members and incorporate found objects delivered by members of the public.

During the same period, Leedy began a series of performance-installations that involved hundreds of art students and members of the general public. The first, in Pori, Finland, took place in 1987, in the aftermath of the April 1986 accident at the Chernobyl nuclear reactor in the Soviet Union. These installations continued in Norway (Bergen, 1993; Oslo, 1994) and in Flagstaff (1997).

The airborne nylon sculptures, the collaboratively created plates and vessels, the murals, and the performance-installations, taken together, have brought new dimensions to Leedy's creativity that are both broadly democratic and psychological. Leedy's excellence and dedication as a teacher have

Sky Art, Kansas City, *1975. Pencil on paper, 22 x 17.*

opposite page: **Sky Art, Kansas City,** *1971. Nylon, 100 yd. x 45 yd.*

had much to do with the outcomes of the collaborations he has overseen. His natural encouragement of students has led, inevitably, to breakthroughs for them, and studio assistants on his large-scale projects have come close to acting as coauthors. In each case, however, the overarching aesthetic plan has been Leedy's, and his plan has been tied to the themes (death, life, hope) of his earlier work. The collaborations have crossed the boundaries of painting, sculpture, and ceramics, moving Leedy toward an art that has variously defied gravity, been rooted in particular communities, and become, although sometimes ephemeral and impermanent, imprinted on the memories of all who have witnessed it.

The social dimension of Leedy's work reached its highest and most complex level in the *Sky Art* series. Using large triangular pieces of nylon alternating with empty spaces, the pieces in this series added airborne ornament to architecture, on a huge scale. A *Sky Art* piece, according to the site and the available budget, might be created especially for an event or it might be recycled or reconfigured. Each of these pieces, comparable in scope to a fireworks display, involved weeks of planning and usually stayed in place for about one week. Its elevation and suspension required the collective efforts of hordes of assistants. It also needed the cooperation of the governmental and university bureaucrats who could grant (or withhold) permits, engineering licenses, and redirections of traffic. It depended as well on the generosity of civic patrons and on the curiosity of an observant public.

When he created the first of these pieces, *Sky Art* (1971), Leedy wanted to draw attention to downtown Kansas City, which was in neglect and in danger of deterioration. This first piece was funded by the Kansas City chapter of the American Institute of Architects and the Missouri Arts Council, as part of Kansas City's annual City in Celebration. It employed City Hall and the 11th and Oak Building as framing devices for a 100-by-45-yard pennantlike assemblage whose triangular/diamond-patterned construction faintly echoed the Art Deco style of

the buildings between which the sculpture was suspended by metal wires. Its elevation, repeated in Kansas City in 1979, 1981, and 1983, was a minor media event and, for Leedy, marked a major step forward, away from the confining solitude of the studio and out into the world.

In addition to the four elevations in Kansas City, *Sky Art* elevations occurred in conjunction with an urban gathering in Chicago (1975) and the Three Rivers Festival in Pittsburgh (1979); both of these elevations were accomplished in collaboration with Cindy Snodgrass, a student at the Kansas City Art Institute. *Sky Art* also made appearances at a festival of the arts in Flagstaff (1983) and at another arts festival in Billings (1984). In Flagstaff and Billings, one additional element enhanced the production and required additional elaborate group efforts: the elevation of a *Sky Art* piece, *Sea Amoeba* (1979), via a hot-air balloon. The elevation outside Flagstaff, where the piece was raised to considerable heights in an extraordinary desert dawn, was Leedy's ultimate attempt to shed the literally earthbound constraints of making ceramics. The artist took on the aura of the Wizard of Oz as, navigating in the balloon's gondola, he was trailed by his own magical creation, which appeared both animated and transparent, like a jellyfish. These balloon forays, freeing the artist from the requisite framing device of tall buildings, were also his attempt to interact with a fragile ecology. Each of these *Sky Art* elevations required intense and lengthy preparation, but the continual effort of construction and group assembly became for Leedy, as for Christo (b. 1935), an aspect of the work's overall aesthetic meaning.

Leedy's ties to Flagstaff stemmed from his close friendships with Bendel, who was also chairman of the art department at Northern Arizona University, and Joel Eide, director of the university museum. In 1980, Leedy had participated with Voulkos and Autio in a series of demonstration workshops during a residency at Northern Arizona University. It was not the first time he had engaged in such collaboration, but this one set off a series of highly popular projects for these three artists; the trio

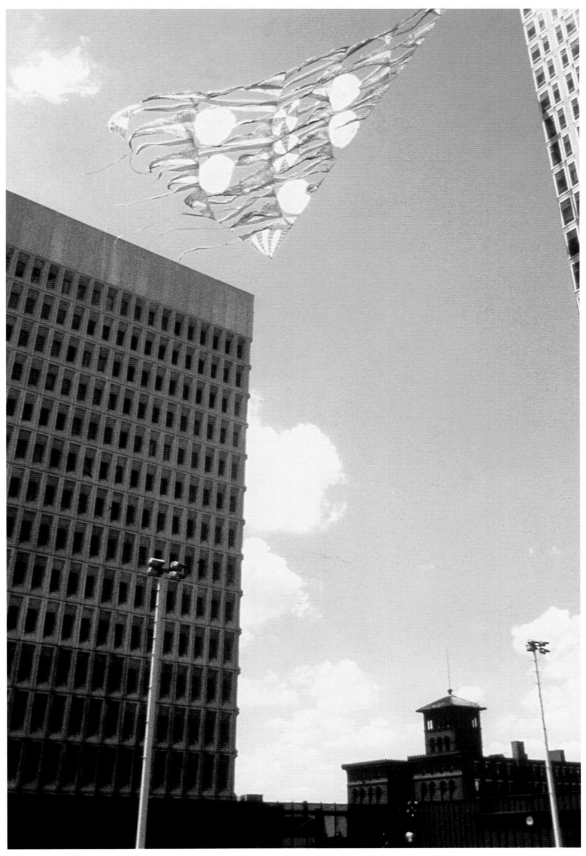

Sky Art Suspended over Kansas City #2, *1979. Nylon, 75 yd. x 75 yd.*

Icarus, *1979. Rip-stop nylon cloth, 100 yd. x 45 yd. View near Flagstaff, Arizona.*

Sea Amoeba, *1979. Rip-stop nylon cloth, 100 yd. x 45 yd. View at dawn near Flasgstaff, Arizona, 1983.*

went on to work together in Berkeley and Helsinki in 1982, and elsewhere over the years. Out of these collaborations there evolved a number of plates and vessels for which Leedy and his two old friends from Montana shared authorship.

These encounters were chronicled in the 1985 exhibition *To Helsinki and Back, 1980–1983: Ceramic Works by Rudy Autio, Jim Leedy & Peter Voulkos.* As Bendel pointed out in his introduction to Eide's catalog of the exhibition, "These creations uphold the professional attitudes of this trio using the tradition of the pot for their sculptures."[1] Nev-

ertheless, although these works were of theoretical interest, they are of variable quality and can now be seen more as Leedy's awkward stepchildren than as fully successful artworks. By comparison with his other collaborations, these ceramic plates and vessels have, metaphorically speaking, the stature of minor footnotes, perhaps because they were, in general, playful workshop performances.

Far more important than the collaboratively produced plates and vessels were Leedy's collaborative public mural projects for Himeji City, in Japan, and

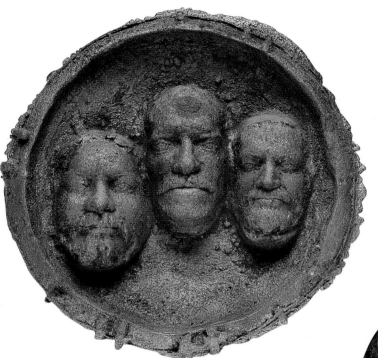

Rudy, Pete and Jim, *1983. Bronze, 23 diam. x 5¾ depth.*

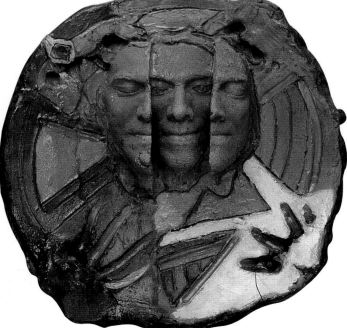

Reitz on Reitz by Leedy, *1987. Glazed stoneware, 20 x 20 x 6.*

103

Edmonton, in the Canadian province of Alberta.

In Himeji City, well known for its castle, Leedy worked closely with Bendel, Reitz, and their fellow artist (and Japanese host) Yukio Yamamoto (b. 1925) on a nine-by-thirty-five-foot ceramic mural. With the idea of bringing about a cultural interchange between the United States and Japan through the shared tradition of wood-fired ceramics, the four artists used the flat mural format as a ground for applied, craterlike ornament in an abstract expressionist style. In addition to creating individual sections, the three Americans and their Japanese host discussed one another's contributions. *Himeji City Mural* (1988) is one of the largest wood-fired stoneware murals in the world, if not the largest. Working as a team, the four artists dispensed with conventional notions of individual authorship in order to take advantage of this extraordinary opportunity for international cooperation.

Leedy's other significant collaborative clay mural project was created for the city of Edmonton's 1992 Works Festival. This eight-by-twelve-foot mural, *The Legacy Project* (1992), combines poly-ester resin casts of human hands and faces with other cast replica objects (such as images of buffalo and of First Nation chieftains), as appropriate to the province's history. Leedy was the presiding artist for this project; community members got involved by lending assistance during the mural's construction and firing and by serving as models for the hand and face casts. With red, yellow, orange, and blue areas symbolizing the colors of a prairie sunrise, the mural's faces, hands, and allusive objects combine to create a stunning impact on the viewer. *The Legacy Project*, the most thematically unified of all Leedy's public projects in its use of faces and body parts, enjoyed a critical and public success that was achieved partly through the presiding artist's openness to the public's responses and partly through his subtle, guiding oversight. The mural is now housed in an Edmonton department store.

Leedy's first major performance-installation occurred in Finland in 1987 at the Cotton Club, a converted factory warehouse, during the Pori International Jazz Festival. The Finnish organizers,

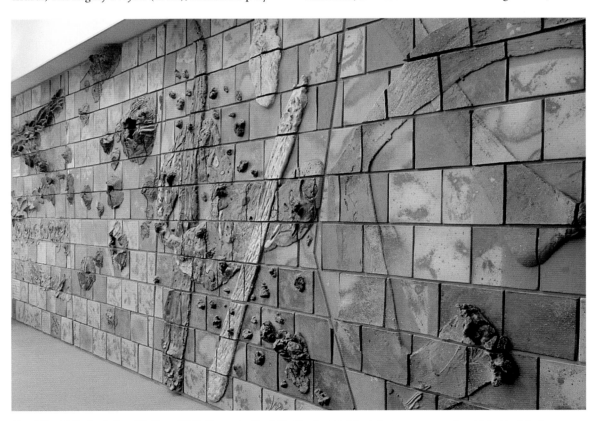

Donald Bendel, Jim Leedy, Donald Reitz, and Yukio Yamamoto: Himeji City Mural, *1988. Wood-fired stoneware, 9 ft. x 35 ft. Municipal government, Himeji City, Japan.*

Collaborations

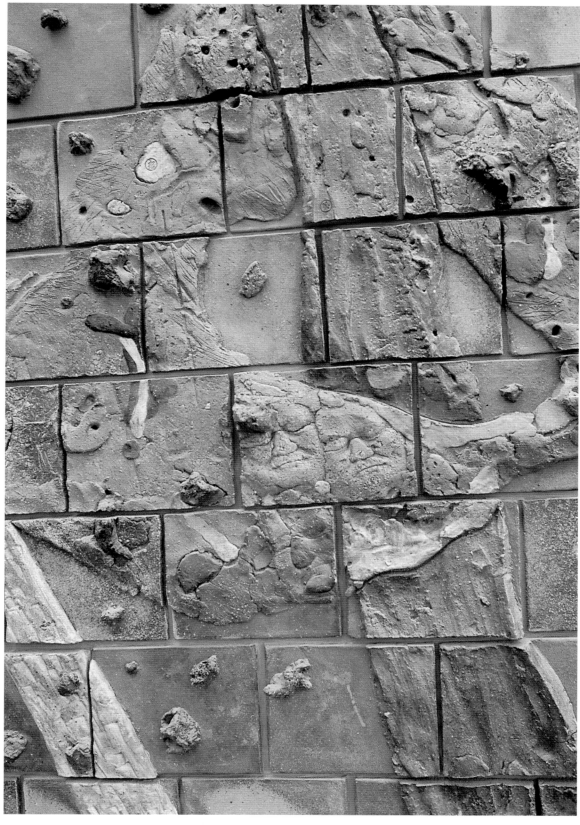

Himeji City Mural *(detail of Leedy section), 1988. Wood-fired stoneware, 9 ft. x 35 ft. Municipal government, Himeji City, Japan.*

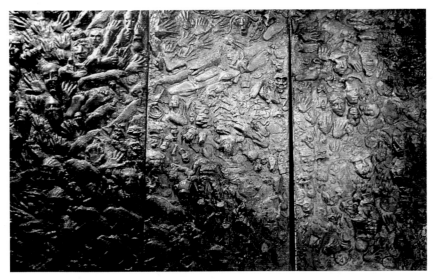

The Legacy Project, *1992. Ceramic and resins, 8 ft. x 12 ft. Created with community involvement.*
Works Festival, Edmonton, Alberta, Canada.

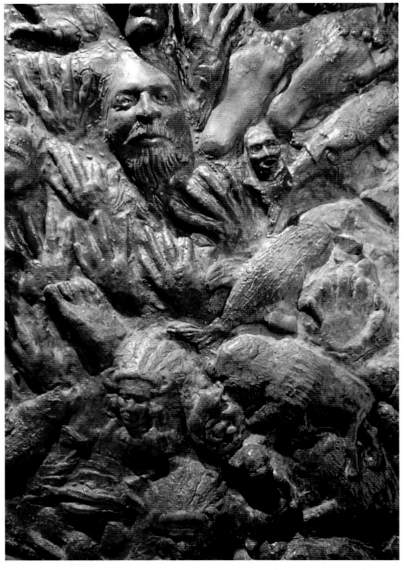

The Legacy Project *(detail), 1992. Ceramic and resins, 8 ft. x 12 ft. Created with community*
involvement. Works Festival, Edmonton, Alberta, Canada.

among them the critic and artist Antero Kare (b. 1946), gave Leedy carte blanche. Leedy's presence in Pori happened to coincide with the period when the Finns were first coping with the aftermath of the partial meltdown at the Chernobyl nuclear reactor, which had occurred in the neighboring Soviet Union on April 25, 1986. Soviet officials had never notified Finland of the accident, but Finland, thanks to its own high-tech atmosphere-monitoring devices, had been the first foreign country to detect the release of radioactivity. Always in a vulnerable position between the two superpowers during the Cold War, Finland had protested strongly to the Soviet government, and relations with the Soviets were strained. Fear of radioactive contamination was running high: milk products were banned for months throughout Scandinavia and other areas of northern Europe.

Leedy, entering into this context, proposed *As the Phoenix Rises, So May Man* (1987), a multimedia installation of clay, rubber, inflated plastic, paint, and metal. Part enormous pile of rubble with secreted human heads, part processional ramp with bleached-out detritus covering the approach to the big pile, *As the Phoenix Rises* involved the eventually enthusiastic collaboration of the dozens of jazz musicians who were in town for the festival. As Kare recalls more than a decade later (letter to the author, July 7, 1999),

> *The studio was an old textile factory which now serves as one of the concert halls. Jim was building the piece with old skis, sand, broken ceramic plates and cups from the Arabia factory and he needed casts of the musicians. The normal suspicions arose with his requests for help until one of the quietest musicians volunteered. The first one got a very relaxing treatment from the taking of the face mask and described it as "beautiful therapy."*
>
> *Next day, a few others came. They enjoyed the vaseline applied, the lying down with eyes closed, and the gypsum warming their face. Because Jim was working long days, he got [back] to the hotel at about midnight. Word had travelled [about his activities], and while*

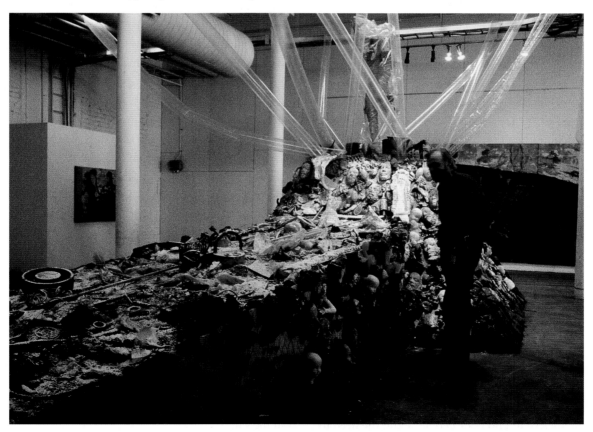

As the Phoenix Rises, So May Man *(detail with artist), 1987. Mixed-media installation. Pori International Jazz Festival, Pori, Finland.*

attending jam sessions he was already [being] greeted as Mr. Leedy, one of the cool guys.

More musicians came the next day. That evening, when he again arrived at the jam, he was noticed at once. People rose up and were fighting for his attention: "I want to donate my hand!" "I want to donate my leg!" "Please, take my head!" They all clamored to become involved.

As the musicians may have guessed, Leedy was emulating the improvisational, collaborative nature of jazz, with which he was fully familiar both as a longtime resident of Kansas City, one of the birthplaces of jazz, and as a guitarist and songwriter.

As the Phoenix Rises, despite the context of its creation and the victims' metaphorical appearance in the central pile, also has an optimistic side. With this work, Leedy transformed a cataclysmic event into an artwork of not just terror and destruction but also human potential by bringing to it his own particular, hopeful vision and by making use of both the human figure and community involvement. This theme of conflict and resolution in regional affairs would return more than a decade later, in *War* (1999), Leedy's most recent mural (see this volume's endpapers and pp. 136, 146, 147).

A temporary installation at the National Academy of Art and Design in Oslo came about at the invitation of Ole Lislerud, chair of the ceramics department. At first the American artist was stymied: How could he help create a giant metal-grid wall installation from recycled materials if Norway was so tidy that none of the students could find any garbage? But when one student brought in a single loaf of day-old bread, Leedy sparked an effort on the part of the entire school to haul in hundreds of loaves, which were freely given by local bakeries. The result was a forty-foot-long assemblage mural of loaves of bread and white ceramic and plaster casts of heads of students, teachers, and other interested parties. Leedy, by extending one student's action, inadvertently struck a chord in the young Norwegians, reminding them, in a country and a city that to all intents and purposes have no homeless and no poor people, about the need to

cope with the basic requirements of daily life. Thus bread, the ur-food from which all else proceeds, and a primal symbol, became a reminder as well of wartime privations suffered during the five-year Nazi occupation (1940–1945). In addition, at the time of the project's execution, Norway, one of the world's most affluent nations, was grappling with an influx of refugees from the war of Serbian aggression in Bosnia-Herzegovina. Norwegians, eager to be seen as citizens of Europe willing to help on the world stage, yet historically and geographically isolated, found their situation mirrored in this student-teacher collaboration at the Oslo branch of the National Academy. The hundreds of faces in the metal-grid wall that was displayed in the gallery of the ceramics department acted as symbols on multiple levels: Norwegians in wartime, suffering Balkan refugees, newly arrived immigrants.

With works like these, so timely and yet temporary in nature, Leedy made a shift to European-style postmodern art. Political content, ephemeral materials as in *arte povera*, and group authorship suggest comparable projects by the German artist and Dusseldorf art academy teacher Joseph Beuys (1921–1986), who also drew on World War II and his own nation's uneasy transition to prosperity.

One final project in Norway, *Clay People* (1993), at the National Academy of Art and Design in Bergen, was both an installation and a performance. For this project, a plastic-lined precinct approximately eight hundred square feet in size, constructed in a glassed-in storefront area by students over a period of two weeks, was filled with furniture and other domestic objects made of tree branches, twigs, and leaves, all eventually covered in clay slip. The construction of this precinct was in preparation for a single evening's performance, the scenario of which Leedy arranged with the students beforehand, this time acting as playwright and "happening" coordinator.

On the night of the performance, Leedy placed a "baptismal" vat of clay slip in the doorway of the storefront space. Visitors who wished to be participant-observers were required to immerse themselves in the vat.

Untitled *(detail), 1994. Mixed-media installation, 8 ft. x 40 ft. National Academy of Art and Design, Oslo, Norway.*

Ole Lislerud *(b. 1950)*, **Domino Wall**, *1996. Ceramic and wood, variable dimensions. Installation at National Museum of Decorative Arts, Trondheim, Norway.*

Antero Kare *(b. 1946)*, **Kindin**, *1996. Acrylic on canvas, 160 cm. x 130 cm. Courtesy of the artist, Helsinki, Finland.*

Clay People delved deeply into Norwegian prehistory. One hour after the immersed participants had become "clay people," assembled as "village residents" and thus summoning up memories of Norway's ancient "bog people," Leedy arrived, completely covered in blue-tinted liquid clay. No one spoke to him or acknowledged his presence at first. It had been agreed, however, that after a while one of the clay people would go over to the blue man, recognize him, and embrace him. At that point, the performance—the culmination of the entire two-week process of *Clay People*'s creation—would come to its formal end.

But the collaborative process was extended still further as the participants, along with the observers who were looking through the storefront window, became critics and interpreters. Most agreed on *Clay People*'s meaning: historically, Norwegians may have been isolated, but eventually they had always

welcomed the friendly outsider. Playing on the Norwegians' nostalgia for a romantic national past, Leedy set in motion a discussion about the status of refugees and immigrants in Norway. Long after the great nineteenth- and twentieth-century exodus from the old country to the New World, Norway had become a desirable migration point for persecuted ethnic minorities. Acceptance of the Other, readily understood by *Clay People*'s audience, is now important to Norway's international prestige.

What had begun as an enigmatic, large-scale class project concluded on a sobering yet viscerally theatrical note. Leedy, crossing another boundary, borrowed narrative aspects of theater to compound the meaning of a site-related performance-installation. His influence on artists in Finland and Norway is still being felt today.

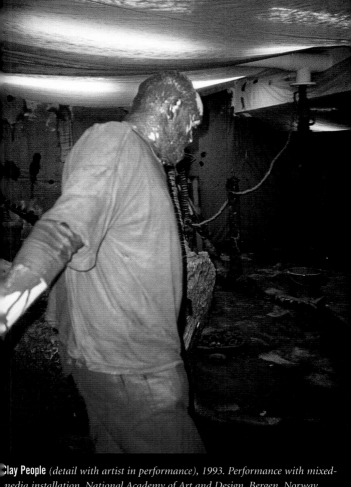

Clay People *(detail with artist in performance), 1993. Performance with mixed-media installation, National Academy of Art and Design, Bergen, Norway.*

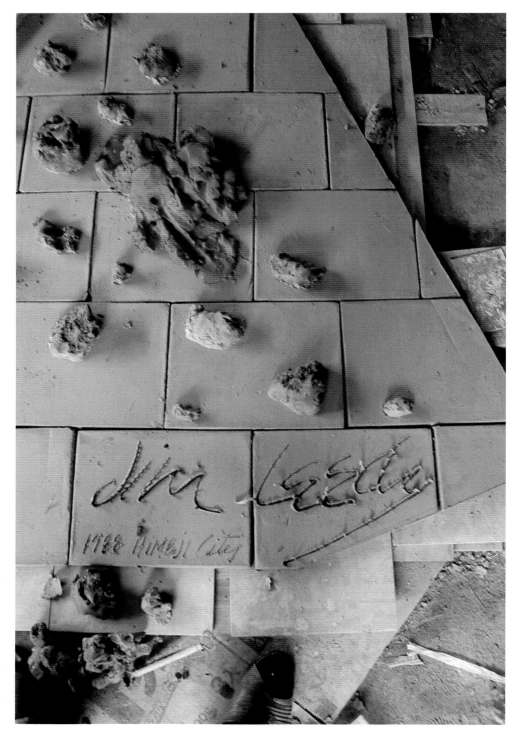

Himeji City Mural *(detail of Leedy signature on unfinished clay panels), 1988. Unfired stoneware. Municipal government, Himeji City, Japan.*

(right) Clay People *(detail), 1993. Performance with mixed-media installation, National Academy of Art and Design, Bergen, Norway.*

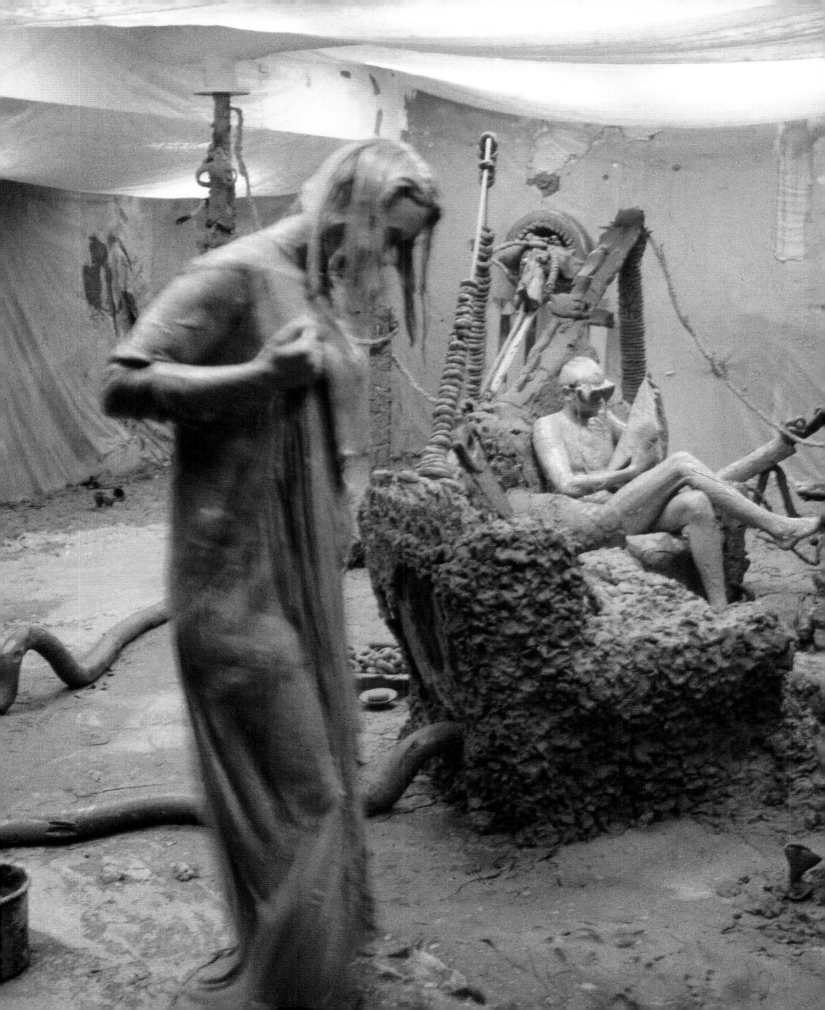

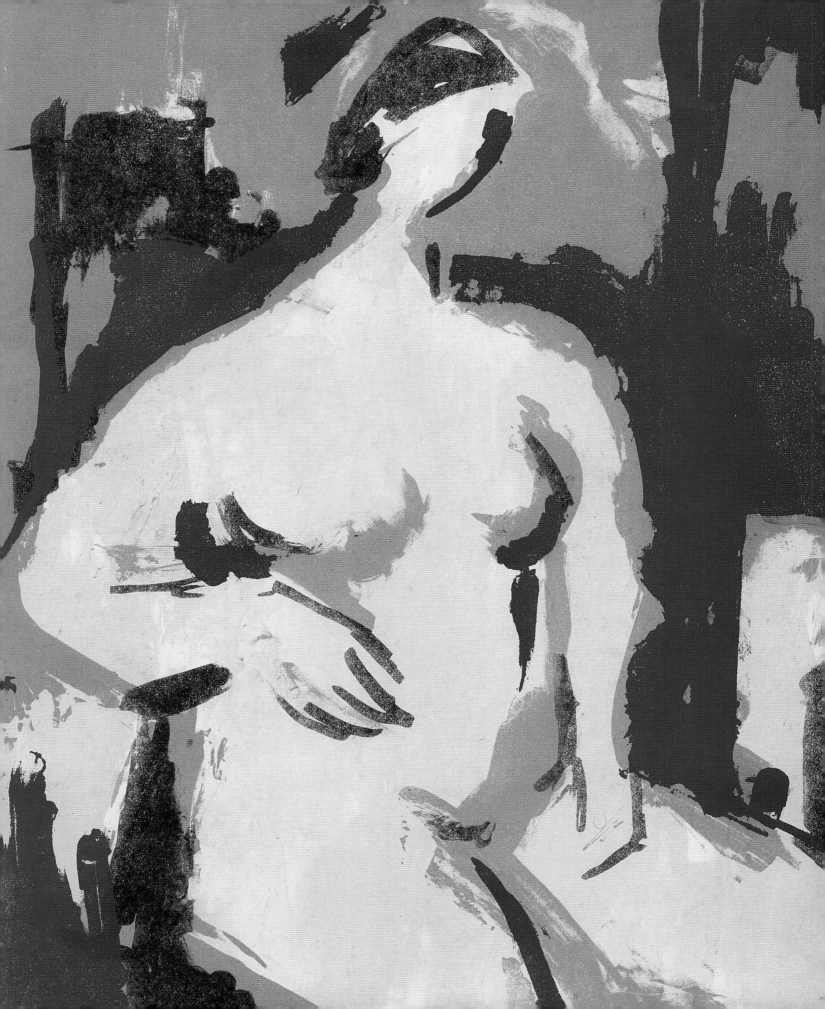

"Line Is the Vehicle"

WORKS ON PAPER

Some people, it seems, are destined from birth to be artists. Draftsmanship, or the ability to record with my hands what I see with my eyes, was born in me. To my parents' surprise, I drew a picture of our dog when I was nine months old and not yet talking properly. Thus, for me, draftsmanship was not learned; it was a natural gift from the start.
—Jim Leedy, "Line Is the Vehicle"

Early in his career, Jim Leedy was fascinated by different printmaking techniques as an extension of qualities of line. The first museum exhibitions in which his work was included were national surveys or juried shows that concentrated on graphic art. As a rule, however, the prints and various works on paper became ancillary to Leedy's paintings and sculptures, although they often dealt with similar images or themes and in some cases proved to be initial expressions of certain key themes or stylistic phases.

The colored lithographs *Seated Woman* (1952) and *Woman* (1954; see p. 11) grew out of abstracted studies of the female nude, such as the painting *Two Women* (1950), itself more a drawing than a painting, and the more mature 1952 painting *Seated Female* (see p. 9). *Seated Woman*, not at all individualized portraiture, uses the female figure as a point of departure for exploration of the clashing colors orange and blue. Two more colored lithographs, *Escaping Spirits* and *Socrates* (both from 1953), proceed with, respectively, double- and multiple-figure groups.

The story of the enforced suicide of the Greek philosopher Socrates, whose ideas were chronicled in the *Dialogues* of his student Plato (ca. 427–ca. 348 B.C.E.), exerted a great attraction on Leedy, who had read the story of Socrates' final hour of life in Plato's *Phaedo*. The decade of the 1950s, of course, was a time when Americans, like the ancient Athe-

nians, were prone to grandiose patriotism and unquestioning acceptance of state authority. This was also a time when Americans who had even remotely liberal political ideas were frequently criticized, as Socrates had been, and put under suspicion of treason. If they were teachers, they also stood in danger of being charged, as Socrates had been, with the corruption of youth. Thus Leedy, who during his U.S. Army stint in Korea had thought a great deal about Socrates' emphasis on ethics and virtue in the face of authoritarian government, paid homage to the father of the humanist teaching method known as the Socratic dialogue, in which one question is answered with another.

Socrates shows the thinker at the moment when the fatal cup is proffered. The composition takes as its model the most famous treatment of

Escaping Spirits, *1953. Lithograph, 18¼ x 14½.*

opposite page: Seated Woman *(detail), 1952. Lithograph, 15 x 11½.*

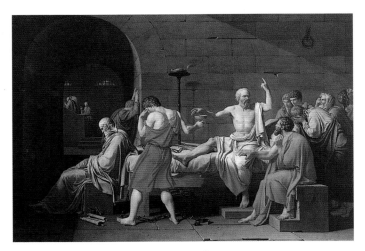

Jacques-Louis David *(1748–1825)*, **The Death of Socrates,** *1787. Oil on canvas, 51 x 75¼. The Metropolitan Museum of Art, New York. Wolfe Fund, 1931. Catherine Lorillard Wolfe Collection.*

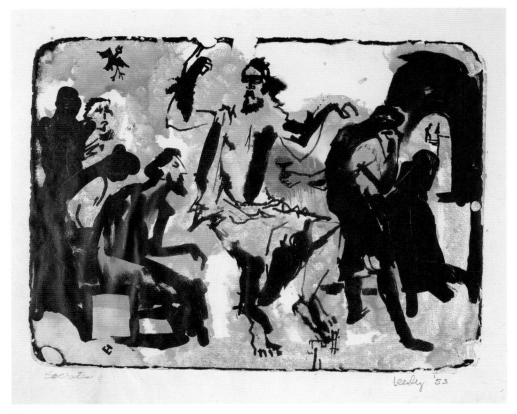

Socrates, *1953. Colored lithograph, 12 x 16.*

the subject, *The Death of Socrates* (1787), by Jacques-Louis David (1748–1825), with the philosopher seated in the center, gesticulating to the end. David had used the story, two years before the French Revolution, to allude to the crushing of dissent by royal authorities; for Leedy, this recourse to the story marked the first of many instances of his evoking a historical event or personage to combine homage with warning. The moral dimension of Leedy's art, often cloaked in modernism, is seen clearly here at an incipient stage. His treatment of the subject, using boldly fluid lines and deftly positioned spots of color, demonstrates perhaps the first example of the abstract expressionist influence on his art:

> In the early '50s, I went to New York to study art history at Columbia University. While there I became friends with the Abstract Expressionists. The now famous . . . Cedar Bar, where de Kooning and others met to drink, fight, and discuss art, was my real training ground. This experience coupled with my studies in Oriental art history and the discovery of Taoism helped me to realize quickly that draftsmanship without substance is a curse. Though I would return to nature for inspiration and confirmation of design, the image coming from the mind replaced the image drawn from an object.[1]

Two hand-colored lithographs, *First Flight* and *Horse and Rider* (both from 1955), are more deeply influenced by abstract expressionism yet also show Leedy closer to finding an individual style. *First Flight*, with its imagery of dynamic motion, anticipates many of Leedy's larger paintings of the late 1990s and was his first fully nonobjective work. *Horse and Rider* may recall the Italian modernist sculptor Marino Marini (1901–1980), but Leedy's familiarity with and love of horses go back to his youth in Virginia and Montana. Here, using the double-figure subject, he explores vertical forms, bold lines, and a highly abstracted treatment of human and animal.

As Leedy wrote in 1985, "Every drawing is made of a combination of marks selected and placed by the artist; this decision-making process becomes the content of the work."[2] *My Son* (1956), which predates *All American Boy Trophy* by more than a decade, employs a colored intaglio etching process to build up a mass of lines enclosing the boy's face. Two other major prints of the next few

First Flight, *1955. Watercolor and lithograph, 22 x 17.*

Horse and Rider, *1955. Hand-colored lithograph, 27 x 20.*

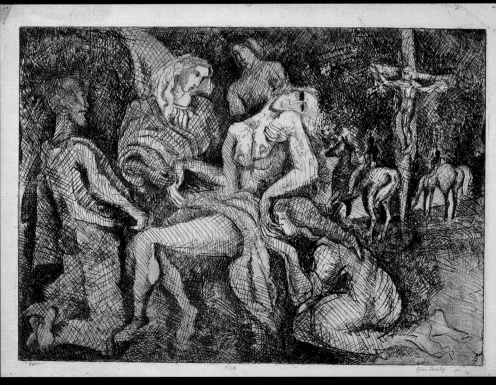

Descention, *1957. Intaglio print on paper, 17¾ x 24.*

years, *Descention* (1957) and *Self-Portrait* (1960), show the artist moving from traditional use of line in printmaking to something much more animated.

Descention is Leedy's most traditional print, in terms of both subject and technical treatment. Not based on any particular art-historical model (although the subject was painted by Rogier van der Weyden, Mantegna, Caravaggio, and others), Leedy's variation on Christ's descent from the cross has a frontal, theatrical presentation of the "players," among whom are the Virgin Mary; the Roman soldier who, according to legend, took Christ's robe; Mary Magdalene; and the soldiers on horseback in the background, near another cross. With the seated, reclining figure of Christ at the center, *Descention* anticipates the composition of Leedy's more notorious 1961 painting *The Annunciation*, which would be attacked by narrow-minded officials at the University of Montana.

Both the drypoint etching *Self-Portrait* (1960)

and the pencil drawing *Self* (1978) show, in surprisingly personal ways, the breadth of Leedy's power over line. From the enraptured, almost devout, upward-looking gaze of *Self-Portrait* to the psychologically tortured and piercing eyes of *Self*, the artist's use of line, in all its forms, as a building block for mass and flesh is also seen as a primal unit in the printmaking process. The first of these two self-portraits, done when the artist was thirty years old, is poignant. The second, drawn when he was forty-eight, is terrifying.

The lithograph *Fear* (1959–1960) foretells the 1965 painting that bears the same title, but the earlier print version is an even more harrowing treatment of a terrified African American. Leedy's lithograph, not at all a stereotypical depiction, in spite of the exaggerated facial features, is a still more prescient reflection of the nation's agonizing struggle over civil rights, at a time when lynchings and police brutality were still widespread.

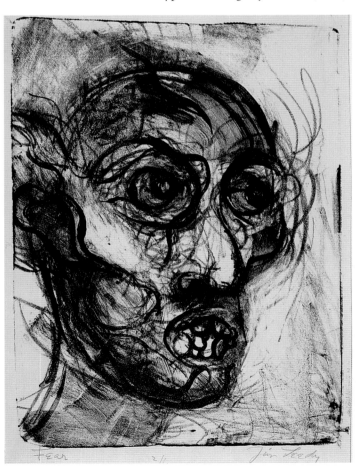

Fear, *1959–1960. Lithograph, 14 x 10.*

All Leedy's drawings for large-scale public art projects are unrealized, with the exception of two or three painted models, mostly from the late 1960s through the mid-1970s—for example, *Maquette* (1963). The drawings and proposals for unbuilt sculptures otherwise constitute another small body of work by Leedy that until now has been unappreciated, not to say unknown.

Leedy's wandering line, which starts out severely geometric, as in *Unbuilt Public Sculpture* (1969), soon finds its way into monuments of extraordinary power. In fact, the title of *Captured Energy* (1969) perfectly suggests the general mood of all the public proposals. *Captured Energy,* simpler in treatment than the subsequent *Variations on a Monument to Anita J. Welch* (1970), evokes an indeterminate, metaphorical force reined in by a giant metal clamp. Later proposal drawings, such as *Site Proposal* (1970) and *For Studies* (1973), combine extremely reductive forms in ways that place Leedy close to, but not in total harmony with, minimal art.

Of far more potential interest is *Floating Forms in Space* (1975), drawn at the height of the artist's nylon *Sky Art* series. As Leedy notes on the

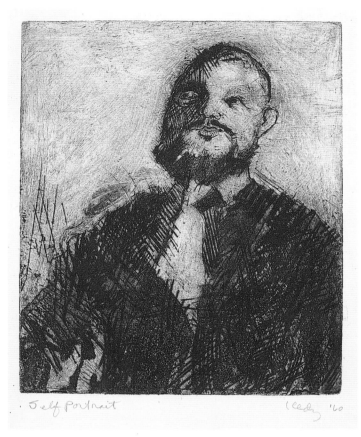

Self-Portrait, *1960. Drypoint etching, 12 x 10.*

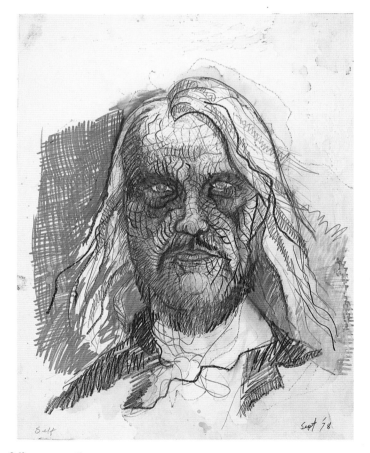

Self, *1978. Pencils on paper, 21½ x 16½.*

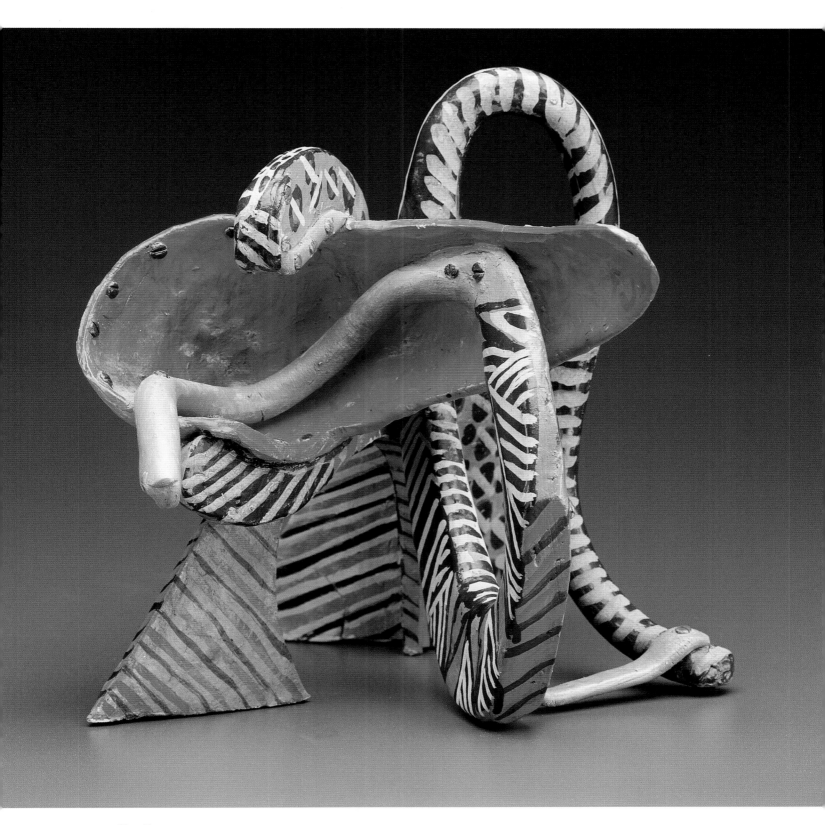

Maquette, *1963. Painted clay, 10¼ x 12½.*

drawing, "helium filled bags floating over downtown K.C., Mo." would have further extended the three-dimensional panoply of his *Sky Art* pieces. *Floating Forms in Space* still deserves to be executed; how it could be resolved and mounted to resemble the grid composition of the drawing remains unclear. Nevertheless, as was also true for other artists of that time who were fascinated by public art, Leedy's ideas, as fantasy public art, are valuable artworks in themselves, and their influence may not be felt for many years. They constitute both a stage in his thinking about three-dimensional objects and an extension of the art of drawing:

The one underlying quality in my work has been, and still is, line. Line is the vehicle with which I travel through the universe of artistic expression. The circle is complete.[3]

Variations on a Monument to Anita J. Welch, *1970. Colored pencil on paper, 22 x 17.*

Captured Energy

Captured Energy, 1969. Watercolor on paper, 22 x 17.

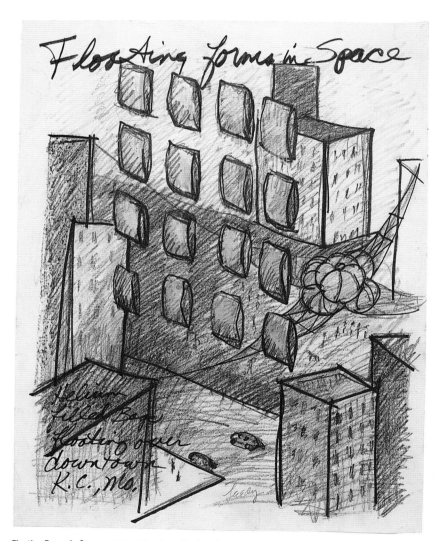

Floating Forms in Space, *1975. Mixed-media drawing on paper, 22 x 17.*

(right) **Public Art Proposal,** *1969. Pencil on paper, 26 x 19¾.*

public art proposal

Leedy '89

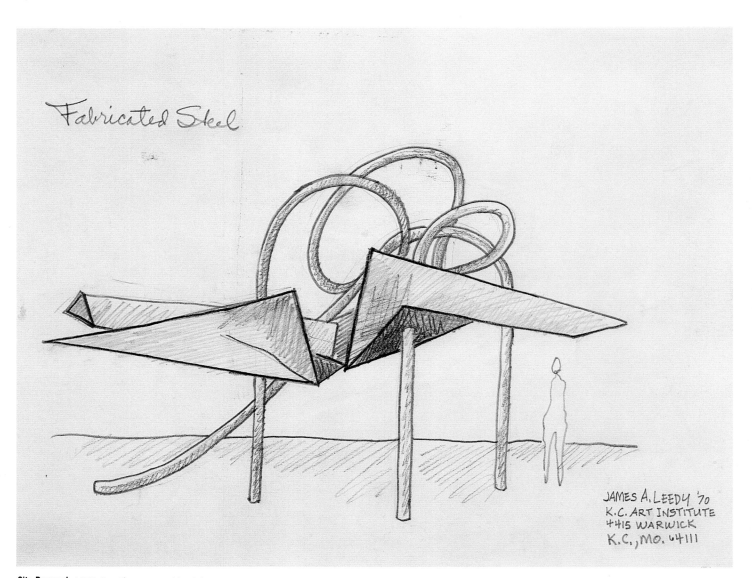

Fabricated Steel

JAMES A. LEEDY '70
K.C. ART INSTITUTE
4415 WARWICK
K.C., MO. 64111

Site Proposal, *1970. Pencil on paper, 11 x 14.*

For studies

Leedy '73

For Studies, *1973. Pencil on paper, 14 x 11.*

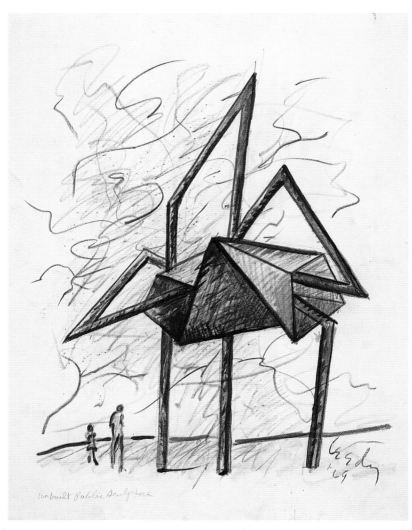

Unbuilt Public Sculpture, *1969. Pencil on paper, 26 x 19¾.*

Self, *1984. Pencil on paper, 28½ x 22½.*

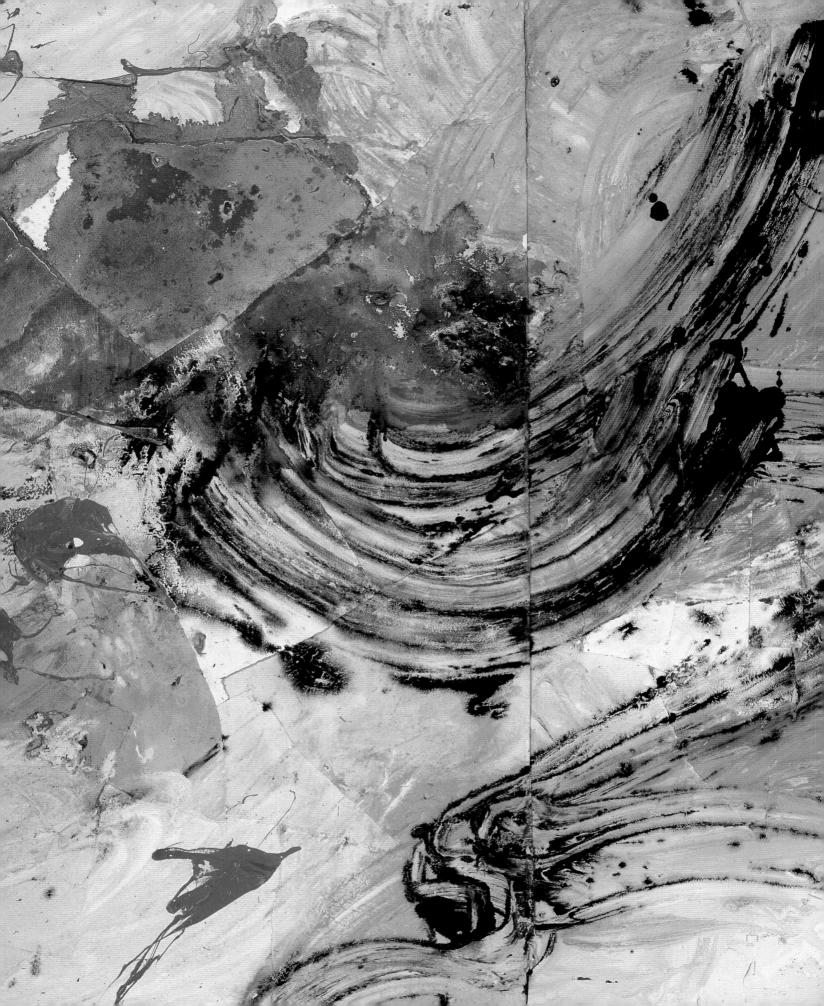

EARTH, WIND, AND FIRE

Earth, wind, and fire have been the three most crucial elements in the art of Jim Leedy, on both literal and metaphorical levels. The earth that became the clay used in his ceramic plates, vessels, and sculptures also exists as the earth of his rural childhood; indeed, it was the very sustenance of his pregnant mother (see "I Am Clay: Ceramic Plates and Vessels" p. 39). It is also the earth that is reflected in the palette of his plates and paintings.

Wind not only was the natural propellant of the *Sky Art* series but also appears as the engine of gesture in the exuberant later paintings, and as the hidden participant within the kiln.

The licking, charring presence of fire has been the animating power in the kiln but also the element responsible, in many cases, for the burnt appearance of the clay and found-object assemblages. Leedy's recent salt-fired stoneware plates expose and exult in the power of fire. Deeper browns and blacks interact with the sandy, rusty, and even caramel-like browns of the fired clay body that Leedy uses. With the untitled plates of the 1992–2000 period, the artist's achievements in ceramics have raised him to a level of impeccable mastery over earth, wind, and fire.

opposite page:
Eternal Birth
*(detail),
1992.
Acrylic
on paper
on wood
diptych,
50¼ x 96.*

During the same period, Leedy's large-scale paintings on paper have shifted from the optimistic, windswept imagery of *Eternal Birth* (1992), a joyous invocation of generative powers, to a somber vision, and to his most explicit statements yet about the horrors and ravages of armed conflict in the late twentieth century. Indeed, the sheer number of lives lost in two world wars (up to seventy million), combined with the carnage of assorted large-scale regional conflagrations in Spain, Algeria, Korea, China, Vietnam, Cambodia, Rwanda, Bosnia, and Kosovo, has pressed in on Leedy as he has contemplated the end of the century, and his own mortality.

The shockingly grim imagery of *Killing Fields I* (1996), with its piles of skeletons against a bloody pink background, and *Unveiled* (1996), a monumental single skeleton, were anticipated by a collaborative print, *Pentimento Skeleton* (1987), in which the artist used a prior colored etching given him by a student and then laid a skeletal torso over the

Expanding Forces II, *1993. Acrylic on paper, 49½ x 41. Harrison Jedel collection, Kansas City, Missouri.*

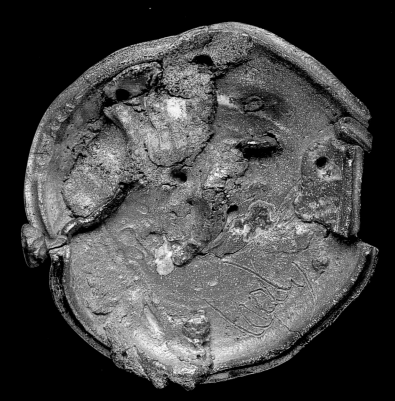

Untitled Plate, *1995. Salt-fired stoneware, 24 diam. x 5 depth.*

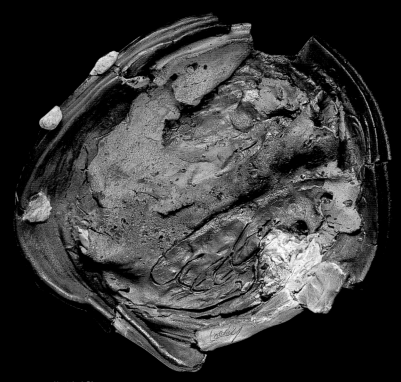

Untitled Plate, *1997. Anagama-fired stoneware, 24½ diam. x 6¼ depth.*

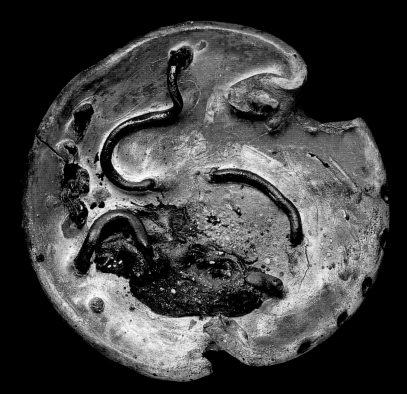

Root Plate, *1997. Anagama-fired stoneware, 27½ diam. x 5¾ depth*

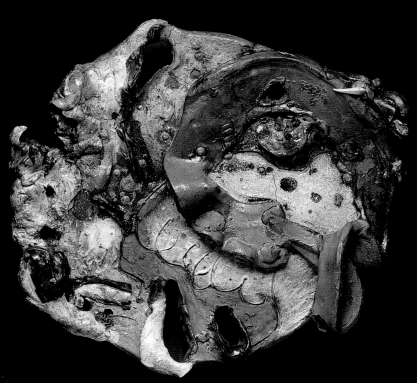

Untitled Plate, *1998. Salt-fired stoneware, 21½ x 24½ x 4¾.*

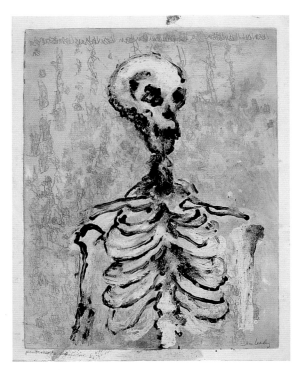

Pentimento Skeleton, 1987. Acrylic on colored etching on paper, 23 x 17½.

underimage, or pentimento, of the original print. *Holocaust* (1993) is one of two specific allusions to the Final Solution. A blood-red-spattered skull dominates the paper, with the letters of the painting's title spaced out vertically along the left edge. Of all the slaughters of this century, Leedy has felt particularly obligated to address the Holocaust of World War II in all its uniqueness, especially with genocide now resurgent since the early 1990s, targeting first the non-Serbs and Muslims of Bosnia, then tribal minorities in Rwanda, and, most recently, ethnic Albanians in the Kosovo region of the former Yugoslavia. *Holocaust* is one of Leedy's most powerful artworks. He returns to the theme of the European Jews' extinction in *Holocaust Memories* (1998), an assemblage painting that combines a ghostly skull with an affixed replica of a child's skull in a black box at the picture's lower left-hand corner.

Leedy's meditation on the Holocaust, as recorded in these pieces, has taken on added urgency in his latest large-scale project, the 1999 work *War*, which brings earth, wind, and fire together into one culminating masterpiece. A forty-seven-foot-long assemblage mural, which Leedy completed at the age of sixty-nine, *War* is simultaneously one of this Korean War veteran's most personal and most public expressions. If the artist was refreshed and inspired by his personal triumphs in Europe (see "Collaborations," p. 108), he did not lose sight of the charnel house that Europe has become in the

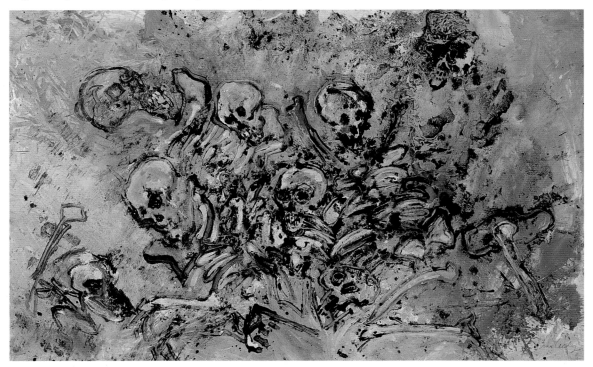

Killing Fields I, *1996. Acrylic on paper, 57½ x 90.*

Earth, Wind, and Fire

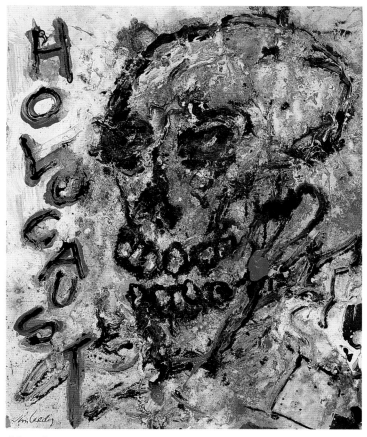

Holocaust, *1993. Acrylic on paper, 28¼ x 22½.*

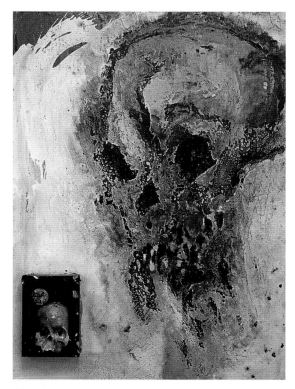

Holocaust Memories, *1998. Oil and acrylic on canvas with mixed media and found object, 46¾ x 34 x 7¼.*

War *(detail), 1999. Mixed media and found objects, 12 ft. x 47 ft.*

twentieth century, and *War* is a comment on that collective catastrophe. Dominated by black and white, the all-over field of *War* suggests miles and miles of bodies, as in the killing fields of Cambodia: indisputable evidence of man's inhumanity to man. Nevertheless, in keeping with his compassion for all forms of life, the mural includes images of animal as well as human skeletons, and it draws attention to the ecological dimensions of war (for example, the catastrophic effects set in motion by the retreating Iraqi army's burning of the oil wells in Kuwait during the 1991 Persian Gulf War). Using the stark realism of found objects, and castings of found objects, *War* is a summation of the horrors of the twentieth century in its last days. Thus, as the bloodiest century in human history comes to an end, Leedy has constructed a magnum opus made

possible by all that came before: the paintings, prints, pots, sculptures, and collaborations.

Such inestimable collective tragedy will very likely continue into the coming century. Where will the next catastrophe occur? After he witnessed wholesale slaughter in Korea, Leedy's awareness of humanity's self-destructive power was also sharpened by his coming of age during the Cold War (1948–1989), a period when the organized nuclear annihilation of the world was an everyday possibility. Because the button was never pushed, however, a tiny streak of optimism may be permitted. In fact, the final panels of birds in flight in *War* could be interpreted as symbolic of escape from catastrophe.

As we conclude our journey with Jim Leedy, having traced his odyssey through the final half of this bloody century, we must not forget his determined (though, to some, irrational) hope. William Faulkner, in his 1949 Nobel Prize acceptance speech, said, "Man will prevail"; in Leedy's *Flight of Survival* (1996–1999), humanity and the natural world are inextricably united, breathing the same air and facing the same environmental and political threats. As a bird soars high above the planet, flapping off into a darkened, unknown universe, a single eye stares out. This exhilarating image of escape, freedom, and survival is another of Leedy's most complex and impressive achievements. In light of his previous accomplishments, there can be only one convincing interpretation: this is the eye of the artist, present at the beginning of time, witness to cosmic origins, birth, death, and, in *Flight of Survival*, to transcendence.

Flight of Survival, *1996–1999. Mixed media on canvas, 66½ x 90½ x 15.*

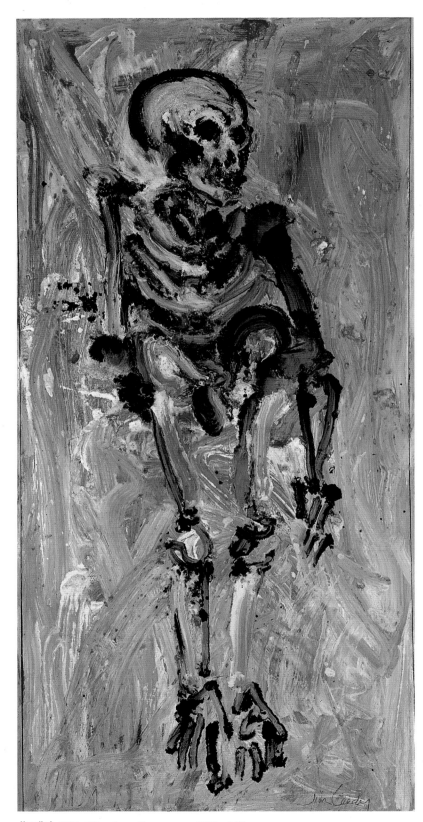

Unveiled, *1996. Oil and acrylic on canvas, 72¾ x 34¾.*

Evolution, *1997. Anagama-fired stoneware, 21¼ x 22 x 5½. Collection Virginia Museum of Fine Arts, Richmond.*

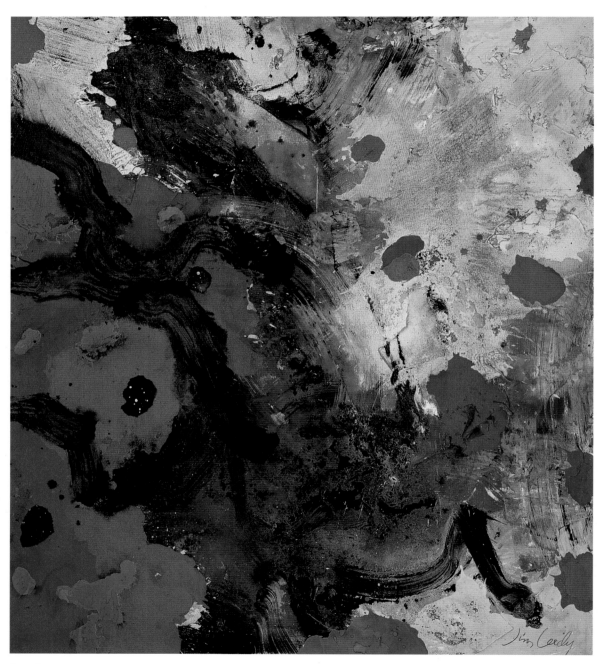

Expansion, *1995. Acrylic and oil on canvas, 54 x 48.*

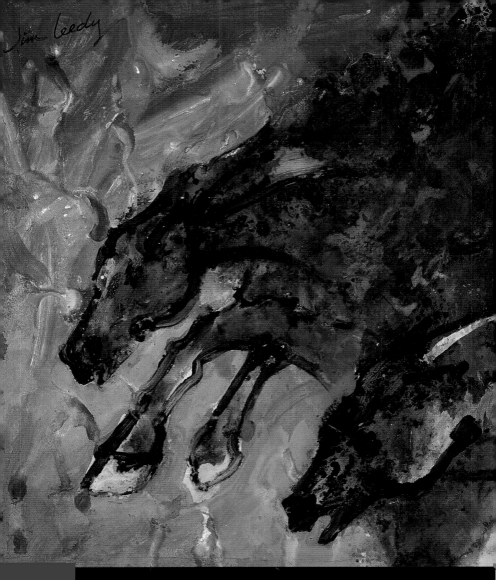

crylic on paper o

...orce, 1997. Salt-fired stoneware, 25 diam. x 5 depth.

Untitled Plate, *1991. Salt-fired stoneware, 21 x 23.*

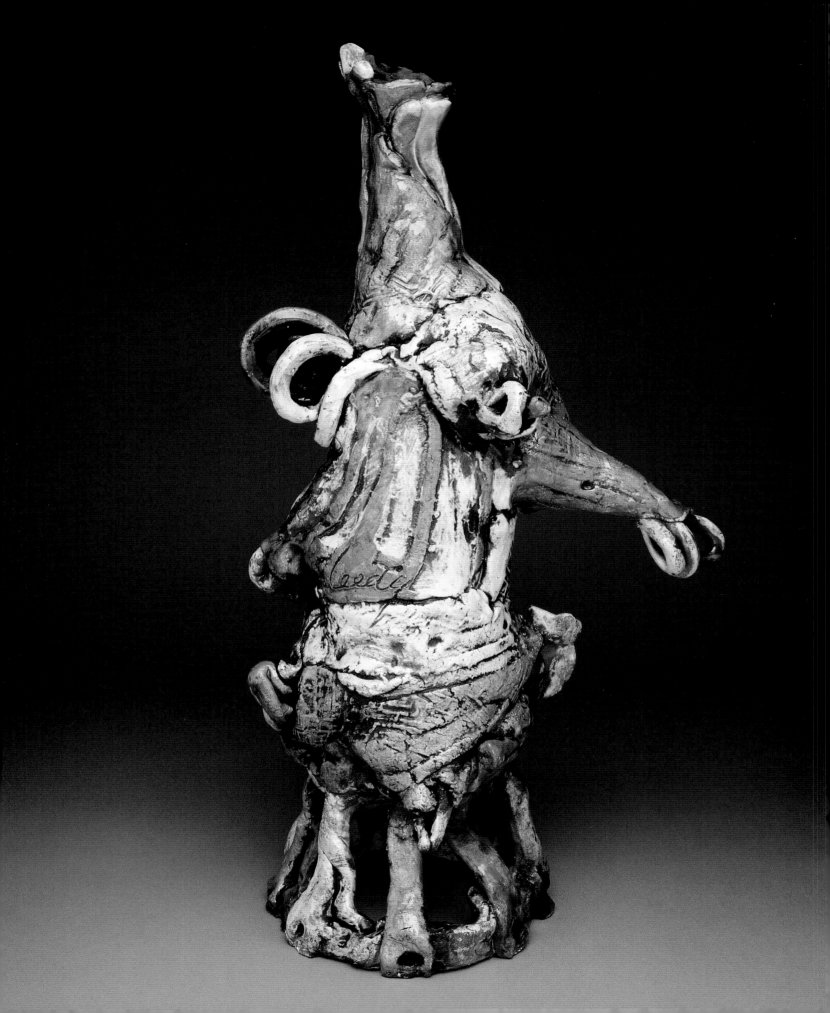

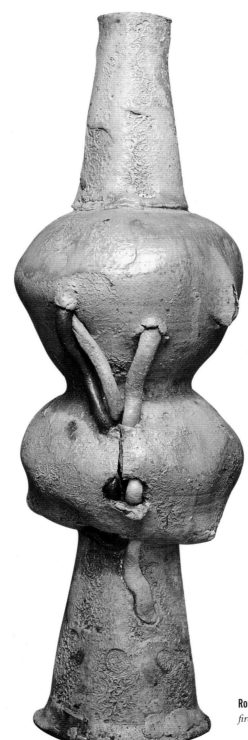

Rounded Stacked Vessel, *1993.* Anagama-*fired stoneware, 46 x 15 x 16.*

(left) Stilted Vessel with Stripes and Loops, *1992. Stoneware, 31¼ x 15 x 13.*

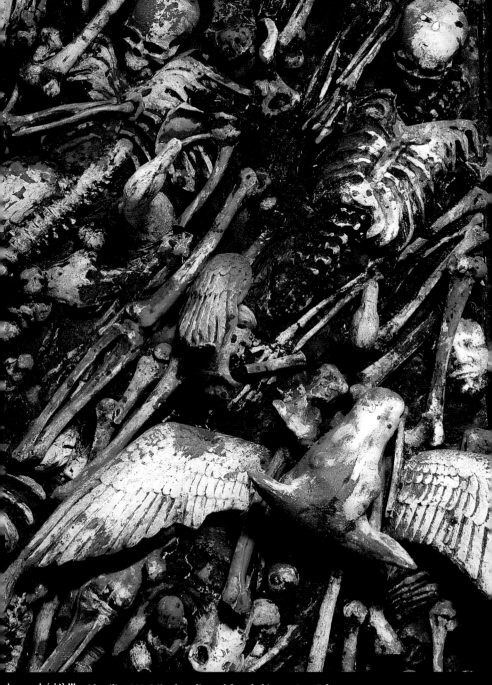

above and right) War *(detail), 1999. Mixed media and found objects, 12 x 47 ft.*

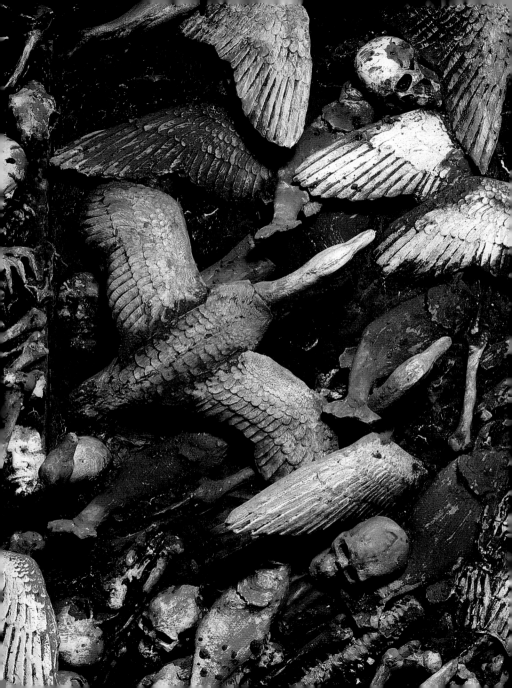

CHRONOLOGY

James Allen Leedy born November 6, 1930, McRoberts, Kentucky

EDUCATION

B.F.A., 1957, Richmond Professional Institute, College of William and Mary (now Virginia Commonwealth University)

M.F.A., 1958, Southern Illinois University

Courses in art history, 1957, 1959, Columbia University

M.A., art history, 1959, Michigan State University

Ph.D. studies, art history, 1958, 1959, Ohio State University

PROFESSIONAL EXPERIENCE

Teaching fellow, Southern Illinois University, 1957–1958

Teaching assistant, Michigan State University, 1958–1959

Teaching assistant, Ohio State University, 1958, 1960

Associate professor, Northern State University, 1959–1960

Associate professor, University of Montana, 1960–1964

Professor, Ohio University, 1964–1966

Professor, Kansas City Art Institute, 1966–present

Founder, Leedy-Voulkos Art Center–Gallery, 1985; codirector, 1985–present; board president, 1988–present

Founder, Kansas City Contemporary Art Center, 1987

Chair, Lakeside Art and Culture International, Lakeside Studios, Lakeside, Michigan, 1990–1995

AWARDS AND HONORS

Merit award, 1957, Richmond Professional Institute of the College of William and Mary

Research grant, 1963, University of Montana

Grant, 1967, Kansas City Regional Council of Higher Education

Fellowship, 1969, Louis Comfort Tiffany Foundation

Grant, 1979, Missouri Arts Council

Grant, 1979, American Institute of Architects

Grant, 1984, Carnegie-Mellon Foundation

Honorary fellowship, 1989, National Council on Education for the Ceramic Arts

Visual artist fellowship, 1990, National Endowment for the Arts

Grant, 1992, Bemis Fellowship for the Arts

Distinguished achievement award, 1995, Kansas City Art Institute

Development grant, 1996, Kansas City Art Institute

Project grant, 1996–2000, Margaret Silva Foundation

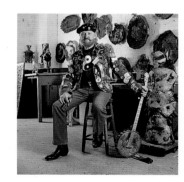

SOLO EXHIBITIONS

1962 Museum of Fine Arts, University of Montana

1963 Art Directions Gallery, New York

1964 Madison Gallery, New York

Oregon State University

1965 Clarion State College

1966 Ohio University

Panoras Gallery, New York

Wilmington College Gallery

1967 Monmouth College

Palmer Gallery, Kansas City

Panoras Gallery, New York

1968 Museum of Contemporary Crafts, New York

1969 Mezzanine Gallery, Nova Scotia College of Art and Design

1970 Crosby Kemper Gallery, Kansas City Art Institute

1971 John Michael Kohler Arts Center, Sheboygan, Wisconsin

1972 Nostalgia Et Cetera Gallery, Baltimore

1974 Stephens College, Columbia, Missouri

1975 Broadway Gallery, Kansas City

Central Iowa Arts Center, Marshalltown

Western Illinois University Art Gallery, Macomb

1977 Illinois Plaza Center, Chicago

1978 Steinberg Gallery of Art, Washington University

1979 Richard E. Beasley Museum and Gallery, Northern Arizona University

Spencer Museum of Art, University of Kansas

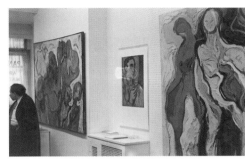

Panoras Gallery exhibition installation, New York, 1966; Mr. Panoras at left.

1981 Museum of Fine Arts, University of Montana

1982 Crosby Kemper Gallery, Kansas City Art Institute

1983 Landfall Press Gallery, Chicago

1984 Morgan Gallery, Kansas City

Eastern Montana College

1986 Morgan Gallery, Kansas City

1990 Leedy-Voulkos Art Center–Gallery (*Conflict of Interest: Then and Now*)

1991 Rochester Art Center, Rochester, Minnesota (*Out of the Ashes/Jim Leedy*)

1992 Leedy-Voulkos Art Center–Gallery (*Jim Leedy: New Paintings*)

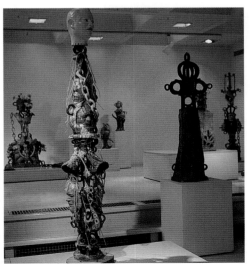

Installation, Museum of Contemporary Crafts, New York, 1968.

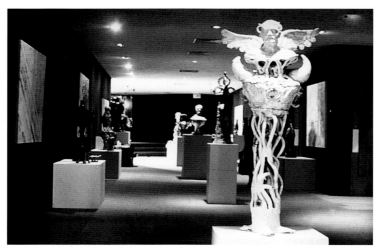

Inaugural exhibition, John Michael Kohler Arts Center, Sheboygan, Wisconsin, 1971.

1993 Bemis Arts Center, Omaha
1995 Goddard Gallery, Stauffacher Center for the Arts, State Fair Community College,
 Sedalia, Missouri
 R. Duane Reed Gallery, Chicago
 Dolphin Gallery, Kansas City (*Jim Leedy: Extension of Nature*)
1997 International Cultural Museum, Himeji City, Japan
 Richard E. Beasley Museum and Gallery, Northern Arizona University
1999 Albrecht-Kemper Museum of Art, St. Joseph, Missouri
2000 Grand Arts, Kansas City (*War*)
 Dolphin Gallery, Kansas City (*Jim Leedy: New Paintings*)
 Leedy-Voulkos Art Center (*Jim Leedy:*
 Unseen Works)

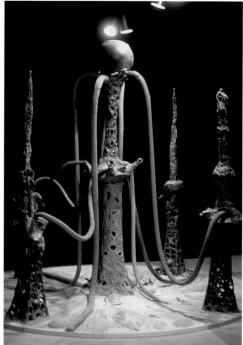

Installation, Baroque '74, *Museum of*
Contemporary Crafts, New York, 1974.

SELECTED GROUP EXHIBITIONS

1959 Detroit Institute of Arts (*Second Biennial of American Painting and Sculpture*)

Art Department, Oklahoma City University (*First National Exhibition of Contemporary American Graphic Art*)

Pennsylvania Academy of Fine Arts (*154th Annual Exhibition of American Painting and Sculpture*)

1960 Pennsylvania Academy of Fine Arts (*155th Annual Exhibition of American Painting and Sculpture*)

1961 Virginia Museum of Fine Arts

Oakland Art Museum (*Bay Printmakers Society, Sixth National Exhibition*)

Henry Art Gallery, University of Washington (*Northwest Printmakers Exhibition*)

1963 Ohio University (*Ultimate Concerns*)

Oklahoma Art Center (*Oklahoma Printmakers Society, Fifth National Exhibition*)

Henry Art Gallery, University of Washington (*Northwest Printmakers Exhibition*)

1964 Dayton Art Institute

St. Paul Art Center, St. Paul, Minnesota (*Seventh Biennial of Fiber–Clay–Metal*)

Thallheimer Gallery, Virginia Commonwealth University

Everson Museum of Art, Syracuse (*23rd Ceramic National Exhibition*)

Cheney Cowles Memorial Museum, Spokane, Washington (*Northwest Printmakers Exhibition*)

Youngstown Gallery of Art, Youngstown, Ohio

1965 Museum of Contemporary Crafts, New York (*Cookie Jars—The Teapot*)

Museum West, San Francisco

1966 Museum of Contemporary Crafts, New York (*Craftsmen U.S.A.,* national tour)

Milwaukee Art Center

Florence Rand Lang Galleries, Scripps College (*21st Annual Ceramics Exhibition*)

Everson Museum of Art, Syracuse (*24th Ceramic National Exhibition*)

1968 Northland College

University of Wisconsin–Madison

1969 National Collection of Fine Arts, Smithsonian Institution, Washington, D.C. (*Objects: USA,* national and international tours)

Nelson-Atkins Museum of Art, Kansas City

Louisville Museum of Art (*Regional Crafts Biennial*)

1970 Everson Museum of Art, Syracuse (*Ceramics '70 Plus Woven Forms*)

Lee Nordness Gallery, New York

1972 Idaho State University

Nelson-Atkins Museum of Art, Kansas City (*Thirty Miles of Art*)

1973 John Michael Kohler Arts Center, Sheboygan, Wisconsin (*Plastic Earth*)

1974 Museum of Contemporary Crafts, New York (*Baroque '74*)

University of Wisconsin–Milwaukee (*Contemporary Statement*)

Philadelphia College of Art

1976	John Michael Kohler Arts Center, Sheboygan, Wisconsin (*Box*)
1978	Thiel College (*100 Teapots*)
	John Michael Kohler Arts Center, Sheboygan, Wisconsin (*Clay Art from Molds: Multiples, Altered Castings, Combinations*)
1979	Towson University (*Function–Non-Function*)
	Seattle Art Museum (*Another Side to Art: Ceramic Sculpture in the Northwest, 1959–1979*)
1980	John Michael Kohler Arts Center, Sheboygan, Wisconsin (*Portraits in Clay*)
1981	Richard E. Beasley Museum and Gallery, Northern Arizona University (*Clay Az Art*)
1982	University of Industrial Arts, Helsinki (*Autio, Leedy, Voulkos—Collaborative Clay Works*)
	John Michael Kohler Arts Center, Sheboygan, Wisconsin (*Paint on Clay*)
	Museum of Fine Arts, University of Montana
	Art Museum of Missoula, Montana
	Richard E. Beasley Museum and Gallery, Northern Arizona University (*Art in Crates*)
	Douglas Drake Gallery, Kansas City (*Dreams and Dislocations: Visionary Images by Kansas City Artists*)
1983	Chicago Cultural Center (*Sea of Life*)
	Nelson-Atkins Museum of Art, Kansas City (*Ceramic Echoes*)
	Crosby Kemper Gallery, Kansas City Art Institute (*Jim Morgan Memorial Exhibition*)
	Vanderslice Gallery, Kansas City Art Institute (*Leedy, Ferguson, Babu, Timock: Clay Works*)
	John Michael Kohler Arts Center, Sheboygan, Wisconsin (*Remains to Be Seen*)
1984	Traver Sutton Gallery, Seattle (*Clay: 1984*)
	Rochester Art Center, Rochester, Minnesota
1985	Richard E. Beasley Museum and Gallery, Northern Arizona University (*To Helsinki and Back, 1980–1983: Ceramic Works by Rudy Autio, Jim Leedy & Peter Voulkos,* regional tour)
	Kansas City Contemporary Art Center (*Voulkos & Leedy & Autio: Clay and Works on Paper*)
1986	Bixby Gallery, Washington University (*Three Dimensions in Mid-America*)
1987	Retretti Art Centre, Retretti, Finland (*Surrealismi—Surrealism*)
	Moderna Museet, Stockholm, Sweden
	Richard E. Beasley Museum and Gallery, Northern Arizona University (*Tozan Kilns: Porcelain/Whiteware Exhibition*)
1988	Katie Gingrass Gallery, Milwaukee (*The American Hand*)
	Corvallis Art Center, Corvallis, Oregon (*The Aesthetic Edge*)
	American Craft Museum, New York (*Ceramics from the Permanent Collection*)
	Retretti Art Centre, Retretti, Finland; Arabia Museum, Helsinki, Finland; Gummesons, Stockholm, Sweden; Museum of Applied Arts, Helsinki (*American Ceramics*)
	John Michael Kohler Arts Center, Sheboygan, Wisconsin (*Celebration*)
1989	Leedy-Voulkos Art Center–Gallery (*Raku: Transforming the Tradition,* national tour)
	Leedy-Voulkos Art Center–Gallery (*Clay Now: Best in American Ceramics*)
1990	Anne Reed Gallery, Ketchum, Idaho (*Sculpture: Visions Transformed*)
	Northern Clay Center, St. Paul, Minnesota (*Minnesota Collects*)
	Erishow Gallery, Nikia-cho, Japan
	Koma Gallery, Himeji City, Japan
	Everson Museum of Art, Syracuse (*Clay, Color, Content: 28th Ceramic National Exhibition*)
	Kunsthallen Brandts Klaedefabrik, Odense, Denmark (*Clay Today*)
	Sculpture Centre, Odense, Denmark (*Gaesteatelier Hollufgard*)
	Pro Arts Gallery, St. Louis
	Nelson-Atkins Museum of Art, Kansas City (*Contemporary American Ceramics*)

1991	The Farrell Collection, Washington, D.C.
	Swidler Gallery, Royal Oak, Michigan (*On the Table—On the Wall: The Platter*)
	Moira James Gallery, Las Vegas (*Beyond Serving*)
	Galería Mesa, Mesa, Arizona (*Wood Spirits*)
	Arizona State University Art Museum (*NCECA National,* national tour)
1992	The Works, Edmonton, Alberta, Canada
	Kunsthallen Brandts Klaedefabrik, Odense, Denmark; Museujm Mensinghe, Roden, Netherlands; Galerie van Aalst, Biest-Houtakker, Netherlands; Galleri Norby, Copenhagen, Denmark (*Clay Today*)
1993	Spiva Art Center, Joplin, Missouri (*Directions: Assemblage and Collage*)
	Dorothy Weiss Gallery, San Francisco (*Rudy Autio/Jim Leedy*)
	Ringebu, Norway (*Keramikk Ringebu—Ceramics Ringebu*)
	Mitchell Museum, Mt. Vernon, Illinois (*Past and Present: Traditions in American Craft Art*)
	Everson Museum of Art, Syracuse (*Fiction, Function, Figuration: 29th Ceramic National Exhibition*)
	Ringebu, Norway; Fine Arts Museum, Lillehammer, Norway; National Museum of Decorative Arts, Trondheim, Norway (*Celebration of the Arts*)
	Arkansas Arts Center, Little Rock (*Working in Other Dimensions: Objects and Drawings*)
1994	Arkansas Arts Center, Little Rock (*Objects and Drawings II: Working in Other Dimensions*)
	Homens Gallery, Ostende, Belgium
	Leedy-Voulkos Art Center–Gallery (*Earthmovers: Autio, Leedy, Voulkos*)
	Galerie Tempo, Roeselare, Belgium (*Heartland,* European tour)
1995	R. Duane Reed Gallery, Chicago
1996	Sybaris Gallery, Royal Oak, Michigan (*Cup: As Metaphor II*)
1997	Museum of Nebraska Art, Kearney (*Rendezvous*)
1998	New Wagner Gallery, Southern Illinois University–Edwardsville (*Wood-Fired Ceramics*)
	Modern Art Museum of Fort Worth (*1998 NCECA Honors and Fellow Exhibition*)
	Rochester Art Center, Rochester, Minnesota (*Sacred Spaces*)
	Appalachian Center for the Arts, Smithville, Tennessee (*Put a Lid on It*)
1999	Hopkins Hall Gallery, Ohio State University (*OSU Ceramics Reunion Exhibition*)
	Cedar Rapids Museum of Art, Cedar Rapids, Iowa (*Rare Earth: Contemporary Expressions in Clay*)
	Fine Arts Center Galleries, Bowling Green State University (*Contemporary Clay: Master Teachers/ Master Students*)
2000	Everson Museum of Art, Syracuse (*30th Ceramic National Exhibition*)
	Los Angeles County Museum of Art (*Defining Moments in Contemporary Ceramics: Smits Collection and Related Works,* national tour)

153

SELECTED PUBLIC COLLECTIONS

American Craft Museum, New York

Anna Leonowens Gallery, Nova Scotia College of Art and Design, Halifax, Nova Scotia

Arabia Museum, Helsinki, Finland

Arizona State University Art Museum, Tempe

Arkansas Arts Center, Little Rock

Central Iowa Art Association, Marshalltown

Daum Museum of Contemporary Art, Stauffacher Center for the Fine Arts, State Fair
 Community College, Sedalia, Missouri

Everson Museum of Art, Syracuse

First National Bank, Columbia, Missouri

Fred Jones Jr. Art Museum, University of Oklahoma–Norman

H & R Block Service Center, Kansas City, Missouri

International Cultural Museum, Himeji, Japan

International Museum of Ceramic Art, Alfred University

Jack S. Blanton Museum of Art, University of Texas–Austin

J. B. Speed Museum of Art, Louisville, Kentucky

John Michael Kohler Arts Center, Sheboygan, Wisconsin

Johnson County Community College, Overland Park, Kansas

Kansas City Art Institute

Kunsthallen Brandts Klaedefabrik, Odense, Denmark

Los Angeles County Museum of Art

Minneapolis Institute of the Arts

Minnesota Museum of Art, St. Paul

Museum of Applied Arts, Helsinki

Museum of Fine Arts, University of Montana

Nelson-Atkins Museum of Art, Kansas City

Philbrook Museum of Art, Tulsa

Renwick Gallery, Smithsonian Institution, Washington, D.C.

Richard E. Beasley Museum and Gallery, Northern Arizona University

Snite Museum of Art, University of Notre Dame

Spencer Museum of Art, University of Kansas–Lawrence

Virginia Museum of Fine Arts, Richmond

Western Illinois University Art Gallery, Macomb

NOTES

INTRODUCTION: ARTIST ACROSS BOUNDARIES

1. Jama Akers, "Jim Leedy: Work in Progress."

2. Michael Cadieux, "Recycled Life," pp. 30, 77.

3. Laura Caruso, *Material, Process and Paradox.*

4. Rose Slivka and Karen Tsujimoto, *The Art of Peter Voulkos.*

PAINTINGS

1. Jama Akers, "Jim Leedy: Work in Progress," p. 57.

2. Matthew Kangas, *Rudy Autio: A Retrospective,* p. 18.

3. Rudy Autio, *Ceramic Sculptures by James Leedy.*

4. Vivian Raynor, "Jim Leedy at Madison Gallery."

"I AM CLAY": CERAMIC PLATES AND VESSELS

1. Patricia Catto and Michael Cadieux, "Jim Leedy: The Re-enchantment of Clay."

2. Rose Slivka, "The New Ceramic Presence."

3. Untranscribed tape of lecture at National Academy of Art and Design, Bergen, Norway, 1993.

4. LaMar Harrington, *Ceramics in the Pacific Northwest.*

5. Peter Selz, *Funk.*

6. Rose Slivka, "The Artist and His Work: Risk and Revelation," p. 38.

7. Ibid., p. 123.

COLLABORATIONS

1. Donald Bendel, *To Helsinki and Back.*

"LINE IS THE VEHICLE": WORKS ON PAPER

1. Jim Leedy, "Line Is the Vehicle."

2. Ibid.

3. Ibid.

WORKS CITED

Akers, Jama. "Jim Leedy: Work in Progress." *Home Design,* Jan. 1998, pp. 56–60.

Autio, Rudy. *Ceramic Sculptures by James Leedy.* New York: Museum of Contemporary Crafts, 1968.

Bendel, Donald. Introduction. In Joel Eide, *To Helsinki and Back, 1980–1983: Ceramic Works by Rudy Autio, Jim Leedy & Peter Voulkos.* Flagstaff: Northern Arizona University, 1985.

Cadieux, Michael. "Recycled Life." *Ceramics Monthly,* May 1982, pp. 30, 77.

Caruso, Laura. *Material, Process and Paradox: The Art of Jim Leedy.* Kansas City, Mo.: Leedy-Voulkos Art Center–Gallery, 1991.

Catto, Patricia, and Cadieux, Michael. "Jim Leedy: The Re-enchantment of Clay." *Ceramics Monthly,* Feb. 1995, pp. 57–60.

Eide, Joel. *To Helsinki and Back, 1980–1983: Ceramic Works by Rudy Autio, Jim Leedy & Peter Voulkos.* Flagstaff: Northern Arizona University, 1985.

Harrington, LaMar. *Ceramics in the Pacific Northwest: A History.* Seattle: University of Washington Press, 1979.

Kangas, Matthew. *Rudy Autio: A Retrospective.* Missoula: University of Montana, 1983.

Leedy, Jim. "Line Is the Vehicle." *Studio Potter,* Dec. 1985, pp. 54–55.

Raynor, Vivian. "Jim Leedy at Madison Gallery." *Arts,* Apr. 1963.

Selz, Peter. *Funk.* Berkeley: University of California Art Museum, 1968.

Slivka, Rose. "The New Ceramic Presence." *Craft Horizons,* July-Aug. 1961, p. 30.

Slivka, Rose. "The Artist and His Work: Risk and Revelation." In Rose Slivka and Karen Tsujimoto, *The Art of Peter Voulkos.* Oakland, Calif: Kodansha International Ltd. and Kodansha America, Inc./The Oakland Museum, 1995, pp. 33–64.

Slivka, Rose, and Tsujimoto, Karen. *The Art of Peter Voulkos.* Oakland, Calif: Kodansha International Ltd. and Kodansha America, Inc./The Oakland Museum, 1995.

BIBLIOGRAPHY

CORRESPONDENCE

Autio, Rudy. Letter to Jim Leedy, May 18, 1983; letter to the board of directors of the National Council for Education on the Ceramic Arts, Jan. 19, 1989.

Benno, Benjamin. Letter to Jim Leedy, Dec. 17, 1959.

Donhauser, Paul. Letter to Jim Leedy, Nov. 12, 1977.

Harrington, LaMar. Letter to Jim Leedy, June 30, 1976.

Leedy, Jim. Letters to Matthew Kangas, March 19, 1989; May 9, 1994; March 1, 1998.

Nordness, Lee. Letter to Jim Leedy, Dec. 11, 1968.

Reitz, Don. Letter to the board of directors of the National Council on Education for the Ceramic Arts, Oct. 25, 1988.

Voulkos, Peter. Letter to the board of directors of the National Council on Education for the Ceramic Arts, Jan. 29, 1989.

INTERVIEWS WITH THE ARTIST

Akers, Jama, and Merrill, Hugh: 1990 (unpublished transcript titled "Interview with an Enigma: Jim Leedy").

Kangas, Matthew: Nov. 11, 1989; Feb. 15, 1998; May 29, 1999 (all three interviews conducted in Kansas City).

Presson, Rebecca: March 21, 1990 (date of broadcast on the National Public Radio network).

PUBLICATIONS BY THE ARTIST

Leedy, Jim. "Line Is the Vehicle." *Studio Potter,* Dec. 1985, pp. 54–55.

Leedy, Jim. In *Keramikk Ringebu—Ringebu Ceramics.* Catalog for ceramics symposium, Ringebu, Norway, 1993.

Leedy, Jim. "Voulkos by Leedy." *Studio Potter,* June 1993.

ADDITIONAL SOURCES

"American Animals: Horses Are a Favorite Subject of Modern American and Ancient Chinese Sculptors." *Scholastic Art,* Feb. 1993.

"Art in Mid-America." *Kansas City Star,* Dec. 31, 1967.

Autio, Rudy. "Montana Revisited." *Ceramics Monthly,* Dec. 1981, p. 91.

Beauchamp, Elizabeth. "Beat-Generation Roots Foundation of Works' Legacy." *Edmonton Journal* (Alberta, Canada), July 3, 1992, p. C6.

Breckenridge, Bruce. "Jim Leedy at John Michael Kohler Arts Center. *Craft Horizons,* Aug. 1971, p. 36.

Brewer, Chris. "Lake Lotawana Man's Sculptures Flying High in Kansas City." *Lee's Summit Journal* (Mo.), June 1, 1979, p. 1.

Cadieux, Michael. "News & Retrospect: Jim Leedy." *Ceramics Monthly,* May 1982, pp. 30, 77.

Caster, Penny. "Pillars of Thought." *Red Deer Advocate* (Alberta, Canada), June 19, 1992.

"Ceramic Art on Exhibit at Moira James." *Las Vegas Sun,* March 21, 1991.

Cohen, Harriet Goodwin. "The Teapot." *Craft Horizons,* May/June 1965, pp. 49–50.

Cowdrick, Charles. "Attracting and Forming the Artistic Gestalt." *Pitch Weekly,* Jan. 1995, pp. 10–15, 19–25.

"A Crafty Show of Learning." *Philadelphia Inquirer,* Apr. 7, 1974.

Crumrine, James. "James Leedy, Museum of Contemporary Crafts." *Craft Horizons,* May 1969, p. 39.

Ferguson, G. "Jim Leedy: Anna Leonowens Gallery, Nova Scotia College of Art." *Artscanada,* Apr. 1969, pp. 44–45.

"Fine Arts Series Announced for 1967–68 at Manitowoc UW Center." *Two Rivers Reporter* (Wisc.), Sept. 20, 1967.

Gibson, Kevin. "National Songwriter Sampler." *Louisville Music News,* March 1994, p. 11.

Gould, Whitney. "U.W. Ceramics Exhibit Grows on Its Viewers." *Capital Times* (Madison, Wisc.), Apr. 28, 1967, p. 14.

Hoffmann, Donald. "Vitality of Life Glimmers in the Visions of Death." *Kansas City Star,* Nov. 15, 1981, p. 8F.

Hoffmann, Donald. "Sometimes the Beauty Is Obscure." *Kansas City Star,* Jan. 8, 1984, p. 6F.

Hoffmann, Donald. "Art Journal: . . . Ceramic Art." *Kansas City Star,* Dec. 22, 1985, p. 11E.

Hollander, R. M. "Conflict of Interest: Works by Jim Leedy." *Borderline,* Jan. 1990, p. 41.

"James Leedy, Museum of Contemporary Crafts." *Craft Horizons,* Nov. 1968.

Kangas, Matthew. "Abstract, Figurative & Narrative: American Ceramics in the Early 1990s." In Everson Museum of Art, *The 28th Ceramic National: Clay, Color, Content.* Syracuse, N.Y.: Everson Museum of Art, 1990, pp. 9–11.

Kangas, Matthew. "Jim Leedy." *American Ceramics,* 1990, *8*(3). 49.

Kangas, Matthew. "Prehistoric Modern." *American Craft,* June/July 1990, pp. 32–39.

Kangas, Matthew. "American Ceramic Sculpture in Crisis." In I[nternational] A[cademy of] C[eramics] and *International Ceramics Symposium/Shigaraki '91* (conference proceedings). Shigaraki, Japan: Ceramic World Shigaraki Executive Committee, 1991, pp. 33–39.

Kangas, Matthew. "Opinion: La sculpture céramique américaine en crise." *La Revue de la céramique et du verre,* 1992, *66*, 48–49.

Kangas, Matthew. "The State of American Ceramics." *Ceramics: Art and Perception,* 1993, *13*, 48–52.

Kangas, Matthew. "Pacific Northwest Crafts in the 1950s." In Barbara Johns (ed.), *Jet Dreams: Art of the Fifties in the Northwest.* Tacoma: Tacoma Art Museum/University of Washington Press, 1995, pp. 81–93.

"Kansas Professor Keeping Things Up to Date in City." *Mail-Star* (Halifax, Nova Scotia, Canada), July 27, 1968.

Kare, Antero. *Surrealismi—Surrealism.* Retretti, Finland: Retretti Art Centre, 1987, pp. 136/137.

Kellogg, Alan. "Art Legend Digs The Works." *Edmonton Journal* (Alberta, Canada), July 8, 1992.

Lacouture, Jay, and Hirsch, Richard. *Raku: Transforming the Tradition.* Kansas City, Mo.: National Council on Education for the Ceramic Arts/The Kansas City Contemporary Art Center, 1989.

Lislerud, Ole. "Jim Leedy: American Original." *Ceramics: Art and Perception,* 1997, *29*, 50–53.

Majure, Janet. "Behind an Artist's 'Conflict Of Interest.'" *Kansas City Star,* Apr. 15, 1990, pp. H1, H5.

Miller, W. Michael. "The Tao of Creativity, According to Jim Leedy." *Pitch Weekly,* June 2–8, 1993.

"Missouri Valley." *Studio Potter,* June 1983, pp. 11, 70–71.

"Modern Artist to Speak." *Oregon State Barometer,* Dec. 3, 1964, p. 1.

"News & Retrospect: Jim Leedy." *Ceramics Monthly,* Apr. 1980, p. 97.

"News & Retrospect: Jim Leedy." *Ceramics Monthly,* May 1981, pp. 79–85.

Nordness, Lee. *Objects: USA.* New York: Viking, 1970, p. 137.

"Paint on Clay." *American Craft,* June/July 1981, p. 41.

Peebles, Debra. "The 'Bad Boys' of Clay." *Ceramics Monthly,* Dec. 1994, pp. 10–14.

Piepenburg, Robert. *Raku Pottery* (2nd ed). Farmington Hills, Mich.: Pebble Press, 1994.

Pierce, Gretchen. "Leedy Ceramics Show Non-Conformist View." *Mail-Star* (Halifax, Nova Scotia, Canada), Feb. 8, 1969.

Shawn, Irvin. "Woodstack 95 into Woodfire." *Ceramic Review,* 1995, *155,* 37.

"The Teapot." *Ceramics Monthly,* Nov. 1965, p. 19.

Tedrick, Lynn. "Local Artist Is Among Top 25." *The Messenger* (Athens, Ohio), Jan. 1, 1965, p. 4.

Thorson, Alice. "Tension of Opposites Creates Emotionally Charged Works." *Kansas City Star,* May 10, 1992, p. H4.

Thorson, Alice. "It's More Than Ice and Snow: Kansas City Artist Jim Leedy Takes Part in Cultural Olympics." *Kansas City Star,* Feb. 26, 1994, pp. E1, E7.

Thorson, Alice. "Change of Season." *Kansas City Star,* March 17, 1995, p. 17.

Totani, Matsuji, and Inoue, Hiroyuki. *Joint Exhibition of Four International Potters.* Himeji City, Japan: Koma Gallery, 1990.

Artist at home of Frank Boyden, Otis, Oregon. Japanese brush painting in collection of Mr. Boyden.

Jim Leedy: Artist Across Boundaries was set in Minion, Minion Expert, Alternate Gothic No. 2, and Helvetica Neue and printed in Hong Kong through Palace Press International on 150 gsm Tripine Matte Artpaper. The hardcover edition is bound in Dymic Saifu cloth and was produced in an edition of 1,200 copies. The slipcase edition was produced in an edition of 250 copies.

The following individuals and institutions are gratefully acknowledged for permission to reproduce images of works by Jim Leedy or other artists, or for waiver of normal requirements for permission: Marsha Beitchman and Larry Giacoletti, American Craft Museum; Mikki Carpenter and Thomas Grischkowsky, Museum of Modern Art, New York; DeAnn M. Dankowski, Minneapolis Institute of Arts; Emil J. Donoval and Bridget Haggerty, John Michael Kohler Arts Center; Michael Flanagan and Tom Piche, Everson Museum of Art; Douglass Freed, Daum Museum of Contemporary Art; Alison Gallup, Visual Artists and Galleries Association; John R. Graham, Western Illinois University Art Gallery/Museum; Bruce Hartmann, Johnson County Community College; Robert Hickerson and Ruth Merz, Spencer Museum of Art, University of Kansas; Jo Lauria, Shaula Coyl, and Cheryle T. Robertson, Los Angeles County Museum of Art; Kelly Lindner, the Estate of Robert Arneson; Marcia Manhart and Kris Kallenberger, The Philbrook Museum of Art; Carolyn Meili and Peter Dykehuis, Anna Leonowens Gallery; Alan Miller and Bonnie Cullen, Seattle Art Museum; R. Duane Reed and Lynn M. Schuberth, R. Duane Reed Gallery; Stacey L. Sherman and Jan Schall, Nelson-Atkins Museum of Art; Snite Museum, University of Notre Dame; Ann Sullivan, Arizona State University Art Museum; and Julie Zeftel, Metropolitan Museum of Art, New York.